Cows on Parade in Chicago

COWS
ON PARADE™
IN CHICAGO

Text:
Mary Ellen Sullivan

Photography:
Simon Koenig

Editor:
Herbert and Rico Berchtold

NeptunArt

To all lovers of Chicago and its Whimsical Cows

3rd edition

Copyright © 1999 by Neptun Verlagsauslieferung AG, 8280 Kreuzlingen, Switzerland
and CowParade WorldWide, Inc., Corporate Center West, West Hartford, CT 06110, USA.

Text: Mary Ellen Sullivan
Photography and Jacket Design: Simon Koenig
Design, Setting: Logotype, Roland Kaufmann
Editor: Herbert and Rico Berchtold

ISBN 3-85923-042-5

Dear Friends:

As Mayor and on behalf of the City of Chicago, thank you for your support of Cows On Parade™. This wonderful exhibit is entertaining Chicagoans and visitors from June 15 until October 31, 1999.

These beautiful and whimsically decorated cows are only one of our city's many public art exhibits. Our 300 Cows On Parade™ demonstrate that art does not have to be either «serious» or «hands-off» for it to be effective and moving. Enjoy them through the summer and into October. In November, many of them are auctioned off to support charitable organizations.

Once again, thank you for supporting this excellent exhibit.

Sincerely,

Richard M. Daley, Mayor

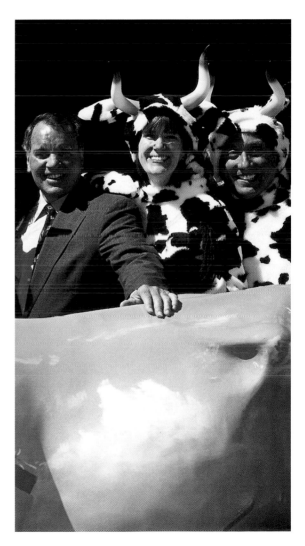

COW PARADE: THE NATIONAL EVENT

The essence of Cows on Parade is the artistic creativity it generates and and the wonderful smiles it brings to the faces of children and adults alike who are touched by the delightful creations. The event is unique in its appeal to people of all backgrounds and ages. We are so pleased to be a part of what has unfolded on the streets of Chicago. The public acclamation which Cows on Parade has received is a glowing testament to Mayor Daley, Commissioner Weisberg and all within the City Government who have labored so enthusiastically to guide this project and assure its success.

CowParade WorldWide, which is headquartered in West Hartford, Connecticut, has been entrusted by the Zurich Retail Trade Association with the responsibility of bringing the Cows on Parade concept to a variety of challenging venues. Chicago has established a standard of excellence which will be a benchmark for all future Cow Parades. We are planning in the next few years to hold this event in other cities in the United States, Europe, and elsewhere. Cows on Parade should be enjoyed by people everywhere. All of us at CowParade World-Wide thank the City of Chicago and its citizens for the opportunity to debut Cows on Parade in the heart of one of the most beautiful cities in America.

Jerome D. Elbaum
President, CowParade WorldWide, Inc.

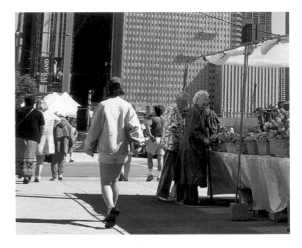

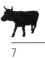
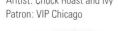

Holy Cow!
Hillary Rodham Clinton
April 14, 1999 A.C.

Clinton Tulip Cow

Aritist: Chuck Roast and Ivy
Patron: VIP Chicago

Maggie Daley

Hey! Hey!
Lura Lynne Ryan

The Consulate General of Switzerland is pleased to have been able to assist the City of Chicago in bringing the Zurich cow event to the Windy City.

I commend the City of Chicago for taking on such an extraordinary and unique project. Zurich, Switzerland and Chicago may be thousands of miles apart, but it is clear that our appreciation of creative projects is very similar.

The success with which Cows on Parade has met here in Chicago is also comparable to that experienced in Zurich with a variety of beneficiaries including artists, retailers, tourism, spectators, and many more.

With Cows on Parade, people from near and far will visit this great city, not only for its beautiful architecture, for its legendary music, or its world-class shopping, but also to view the cows that came from Switzerland. In addition, as I observe the Cows on Parade exhibit, I notice it strikes discussion between people, both Chicagoans and visitors, who normally would pass each other by.

With this book, the memories of this public art event will be available for years to come.

Respectfully,

Eduard Jaun
Consul General of Switzerland, Chicago

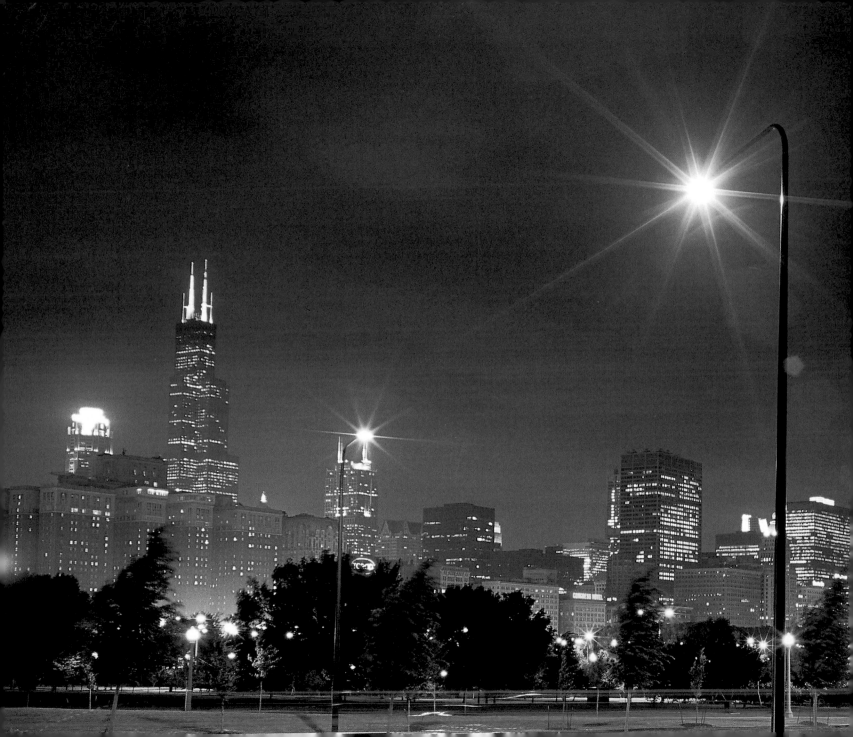

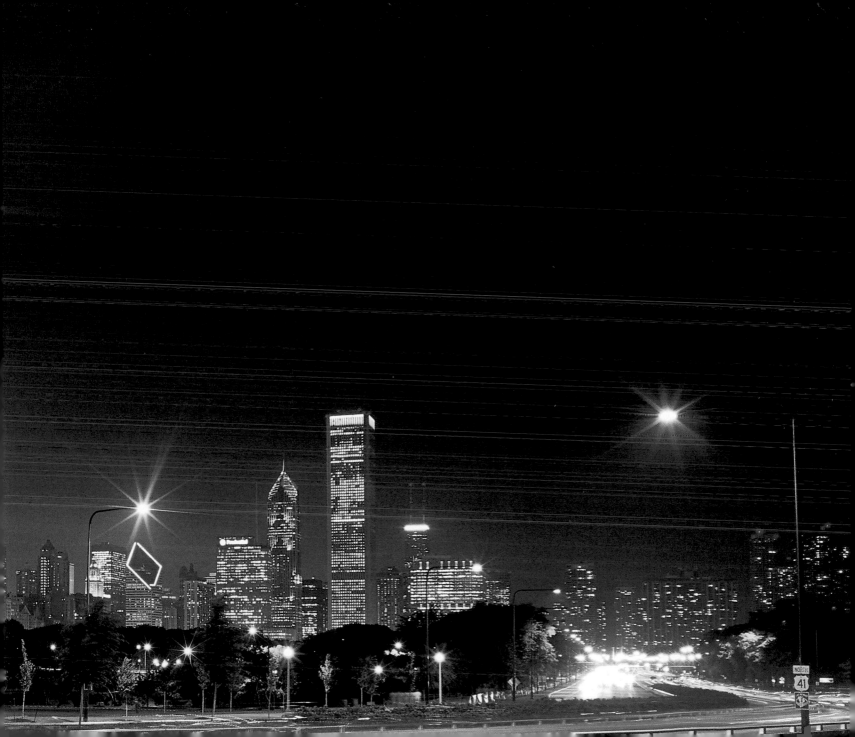

Daniel Nack, Salvatore Ferragamo
Michael C. Christ, Tiffany & Co.
Peter Hanig, Hanig's Footwear

Photo: Michael Schmitt

The question on everyone's lips, of course, is: Why cows? And that question begets another: Why Chicago?

It all started with Chicago businessman Peter Hanig, owner of Hanig's Footwear, who, while on vacation in Switzerland during the summer of 1998, stumbled onto Zurich's massive public art project, «Cow Parade»™, and became enchanted with it. For two days he and his family toured the city, finding one decorated cow more delightful than the next. Back in Chicago, he couldn't stop thinking about the cows and the impact they had had on Zurich — not only did the exhibit bring more than one million additional visitors to the city, but people had fallen in love with the cows themselves. Hanig, a man as passionate about art as he is about the city of Chicago, thought why not host a similar exhibit here?

From there, things moved quickly. Hanig first approached the Greater North Michigan Avenue Business Association, where he's a member, about sponsoring the show along the Magnificent Mile. Initially, people were a bit skeptical; after all, it *is* a wacky idea — scattering life-sized painted and sculpted fiberglass cows down Chicago's toniest street. However, association chairs Michael Christ, of Tiffany & Co., and Daniel Nack of Salvatore Ferragamo, were already familiar with the exhibit and thought a Chicago version of the show worth exploring.

Hanig corralled Swiss Consul General Eduard Jaun and representatives from the group sponsoring Swiss Week in Chicago together with the Greater North Michigan Avenue Business Association and presented the idea once again. This time he used photos to showcase the cows in all their whimsical, artistic glory. Everyone at the meeting fell as hard for the cows as Hanig had first done in Zurich. However, they saw the potential for «Cow Parade» to be a citywide, not just a Michigan Avenue, event, so they got in touch with Chicago's Department of Cultural Affairs. Commissioner Lois Weisberg loved the idea too, and within a week had secured seed money from the Illinois Department of Commerce and Community Affairs. The Chicago Office of Tourism also signed on as a co-sponsor. Just months after Hanig's return from Zurich, «Cows on Parade»™, Chicago-style, was born.

From the beginning, there were sevcral differences between the Zurich and the Chicago event. Zurich had 800 cows placed throughout the city, whereas Chicago planned to have approximately 300 concentrated mostly along Michigan Avenue, the Loop, River North and the new Museum Campus. The Zurich show was two years in the making, while Chicago was pulling its together in about nine months. But the spirit of the event remained the same: Merging art and commerce for public enjoyment. In both cities, local artists designed the cows,

Cows under construction

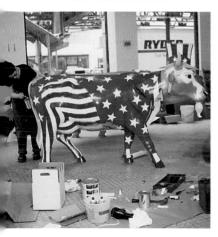

and local businesses and cultural institutions sponsored them.

To make the event happen, Ferragamo's Daniel Nack assembled a herd of «Cow Hands»: A volunteer sales team who contacted corporations, museums, cultural institutions, ad agencies, stores, not-for-profit organizations and even individuals as potential sponsors. Sponsors could purchase unpainted cows, then either hire their own artists to decorate them or use any of the artists that Chicago's Public Art office had invited to participate. For everyone involved, it was a win-win proposition. Artists received modest commissions for their work, but also had the opportunity to participate in an important public art project with potential exposure to millions of people. Sponsors not only supported a worthwhile cause, but also received a tax deduction. After the show's conclusion on October 31, 1999, sponsors can choose to either keep their cows or sell them at the massive «cattle auction» – reminiscent of those once held in Chicago's famed stockyards – planned in early November at the Chicago Theater. The money the cows fetch will then be donated to the charity of the sponsor's choice.

While all of the sponsor activity was taking place, the Department of Cultural Affairs got busy recruiting artists and scouting locations. A cattle call went out to thousands of artists – ranging from high school and Art Institute students to Chicago's most well-known artists and architects. «Cow-ordinator» Nathan Mason served as artist liaison, and the artists began submitting cow designs for approval. Sponsors could then make their selections from approximately 2000 proposals.

To encourage creativity, parameters were set wide; in accord with public art standards, however, there were restrictions against blatant advertising, political slogans, religious messages, gang symbols and inappropriate images. Artists' plans ranged from the subdued to the sublime, and cows soon were being sanded, painted, plastered, bejeweled, bespectacled and augmented. One was wired for sound. Several were cut into sections. Many were put into shoes, and one was even given prosthetic limbs. Some appeared in costume, while others were disguised as cars, pigs, bison, waiters, news vendors, movie stars and machines. As the creative work progressed, funny things started to happen: Artists grew extremely attached to their cows and only reluctantly surrendered them for exhibit; entire neighborhoods where artists worked watched in fascination as the naked cows were transformed into high concept art; and a rash of cow sightings popped up across the city – from reports of cows mounted on wheels to bovines tied to car roofs in transit.

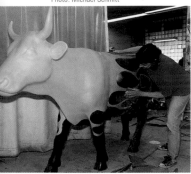

Photo: Michael Schmitt

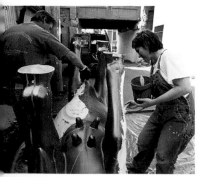

Artists perform some final tweaking on their cows.

Chicago's largest temporary public art exhibit was unveiled on June 15, 1999, with a celebration in Daley Plaza presided over by Mayor Daley and Cultural Commissioner Lois Weisberg. On hand were the Swiss Consul, sponsors, organizers, many of the artists themselves – including the mastermind behind the original Zurich project, Beat Seeberger-Quin – and, of course, the stars of the show: The cows. From the start, the cows were greeted with enthusiasm, affection and a touch of silliness. An *a cappella* group composed of lawyers dressed in cow suits even serenaded the assembled herd.

But what was most overwhelming, and unexpected, was the public response: Chicagoans simply went crazy for the cows. People, young and old alike, from all walks of life, representing every ethnic group and race, reacted to these whimsical sculptures with pure delight. Serious-faced, business-suited executives would walk by these bovines and then crack a broad smile. Children tried to milk the udders. Tourists photographed cows *en masse*. Skateboarding teenagers called out to their favorites as they whizzed by. City dwellers who normally wouldn't turn a head, stopped dead in their tracks to inspect the bodacious bovines in their path. Strangers shared their opinions about art across the back of a cow. People speculated aloud to passersby about the artists' intentions or the meaning of a title. The Chicago Sun-Times newspaper started a «My Favorite Cow» section. An enterprising Streetwise vendor created his own «cow tour». And across the city, cows were petted and stroked, climbed on and shimmied under, photographed and dissected, stared at, smiled at, talked to and hugged. Almost as quickly as the cows appeared on the streets of Chicago, they were accepted as part of the landscape and part of the citywide celebration Chicagoans call summer.

Which brings back the original questions: Why cows and why Chicago? Peter Hanig thinks the appeal of cows has something to do with what they represent. «They are large but non-threatening, maternal, nurturing and friendly,» he says. «They're familiar, but because they are not part of our day-to-day life, their presence in the city causes surprise.» The surprise element is key, Hanig believes, because it captures people's attention and spurs them to think about art in a new way. «Art is about breaking down barriers. It gets people to feel, to think, to react. So when you come across life-sized cow sculptures that have been covered in mirrors or gumdrops, cows that have been painted with elaborate themes or transformed into something else entirely, you can't help but stop to think about what it means. All your preconceived ideas go out the window. Suddenly people see that art can be fun and that art can be interesting to everyone – not just to people who frequent museums.»

Photo: Michael Schmitt

Cow Hand Nina Newhouser shows off the artist's final sketch of a cow in progress.

Exactly the point, says Michael Lash, the director of Public Art for the City of Chicago. «This project is not meant to be high art, it's meant to be accessible. It is doing exactly what it is meant to do.» And because Chicago has a long tradition of public art, the «Cows on Parade» is particularly well-suited to the city. Works by Picasso, Miro, Chagall, Calder and Dubuffet grace the city's plazas. The Picasso at Daley Plaza, in particular, is as identified with Chicago as any of its landmarks

In addition, Chicago's design and feel – with its tall buildings that have been called «sculptures against the sky» and its wide open spaces that never let you forget you're in the Midwest – make it an ideal backdrop for a herd of 300 sculptures to take up residence for the summer. «The way they're juxtaposed against buildings and plazas, as well as placed in road median strips, in gardens, on bridges and boats, makes it all the more interesting,» comments Hanig. «It's as if the cows have become a part of the city themselves. The amazingly positive reaction by Chicagoans tells us that people are desperate for fun, for lively visual interest – and that they are starved for a sense of community. As wacky as it sounds, the cows give us all something to connect with, something that makes us talk with each other, something that makes us happy.» That's as good a case for cows in Chicago as there's ever been.

Holding pen: The Cow House at State and Lake Streets where cows await installation.

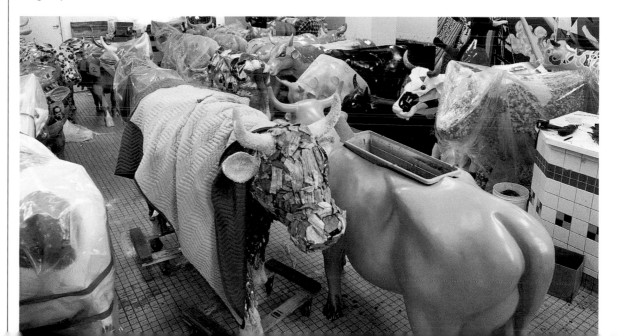

Cows on Parade is perfect for
Chicago's parks: It is a fun display
of public art that looks great against
the natural canvas of our parks.
The Chicago Park District cows are
particulary engaging and will put a
smile on the face of every person
that sees them.

In the front Eduard Jaun, Consul
General of Switzerland, second
right Michael Lash, Director of the
Public Art Program, in the center
Beat Seeberger-Quin, creator of the
Zurich Cow Parade.

U.S.

Artist: Anne Wiens
Patron: Chicago Park District

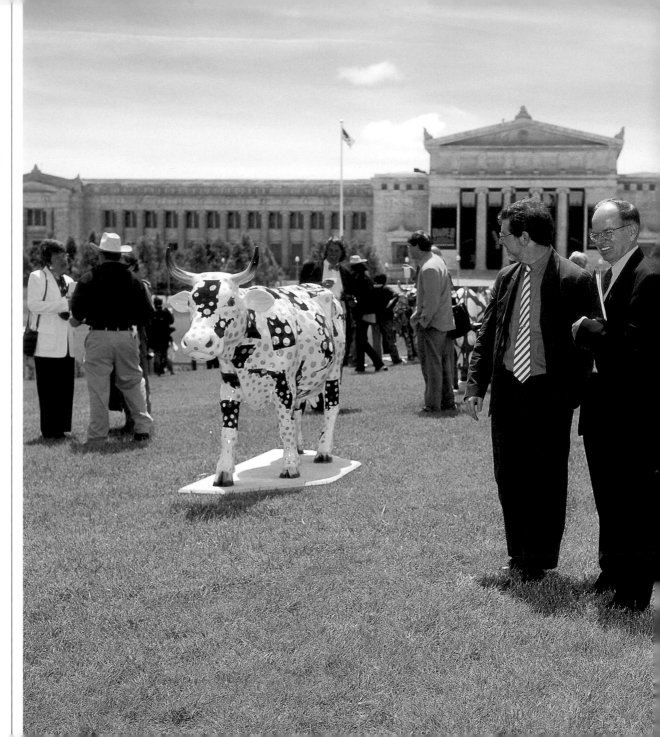

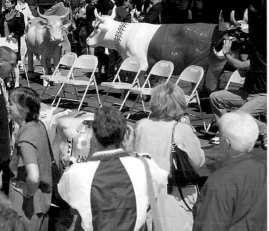

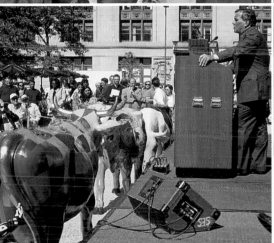

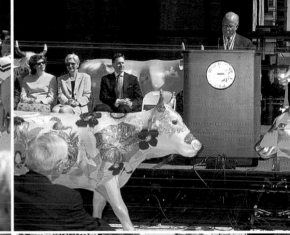

THE PARADE BEGINS

Wow Cow

Artist: Chris Silva
Patron: Chicago Park District
Location: On the beach

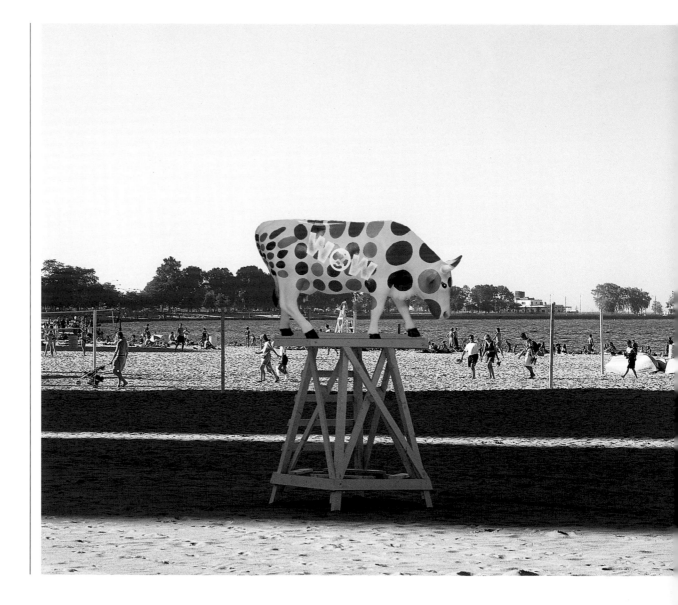

OAK STREET

Moovie Cow

Artist: Marwen Foundation
Patron: Lakewest, Inc.
Location: 58 E. Oak

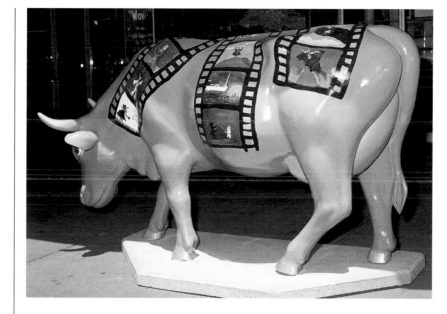

The Adventures of Donald Pliner in Miami

Artist: Lisa Pliner
Patron: Donald J. Pliner
Location: 100 E. Oak

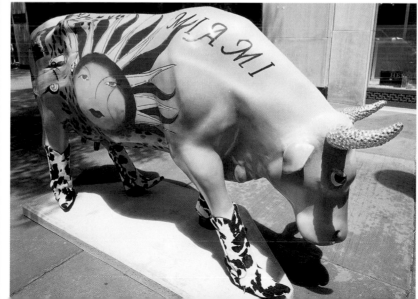

THE MAGNIFICENT MILE

MICHIGAN AVENUE
(Oak to Chicago)

Moveena Newhaus

(Move in a New House)
Artist: Jacqueline Moses
Patron: Rubloff Residential
Properties
Location: 980 N. Michigan

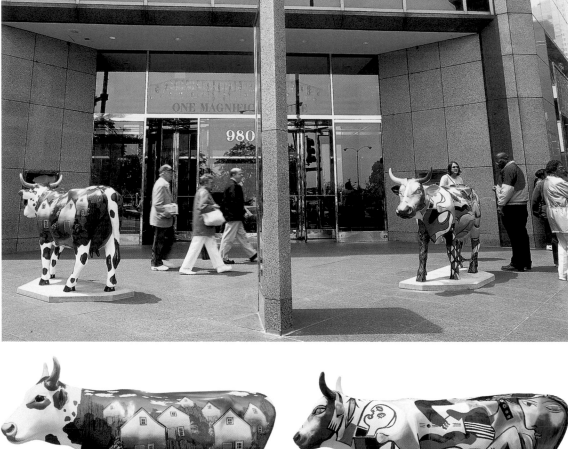

piCOWsso

Artists: Todd Treleven,
Jeff McMahon, Scott Wallace
Patron: Euro RSCG Tatham
Location: 980 N. Michigan

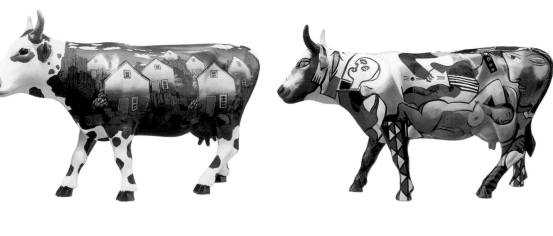

Day and Night

Artist: Tom McGarry
Patron: Westin Hotel
Location: 909 N. Michigan Ave.

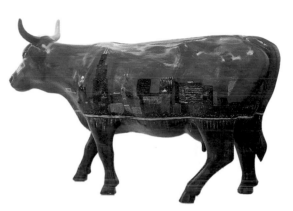

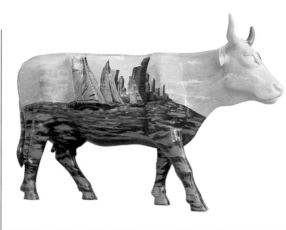

Vanity

Artist: Perspectives Charter School/
CYSF/Pace Partner
Patron: 900 N. Michigan Ave.
Location: 900 N. Michigan Ave.
(second floor)

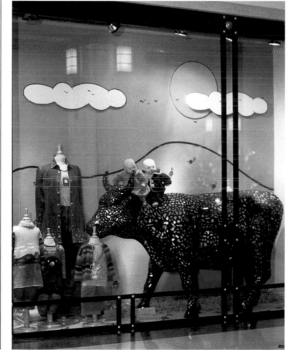

Brian the Cow: Milk and Cookies

Artist: Dennis Callahan
Patron: Doubletree Guest Suites
Chicago
Location: 198 E. Delaware Pl.

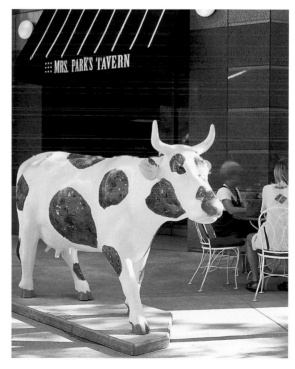

Rhinestone Cowgirl

Artist: Linda Dolack
Patron: Stuart Weitzman, Inc.
Location: 900 N. Michigan

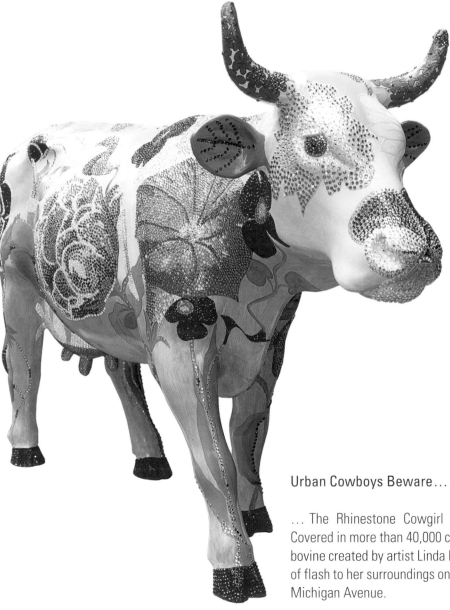

Urban Cowboys Beware…

… The Rhinestone Cowgirl has come to town. Covered in more than 40,000 crystals, this beautiful bovine created by artist Linda Dolack brings a touch of flash to her surroundings on the ever-fashionable Michigan Avenue.

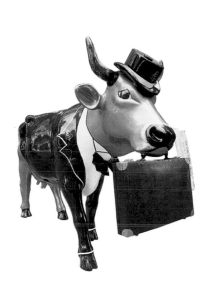

Belle, a Cow for All Seasons

Artist: Four Seasons Engineering
Department
Patron: Four Seasons Hotel
Location: 120 E. Delawarc

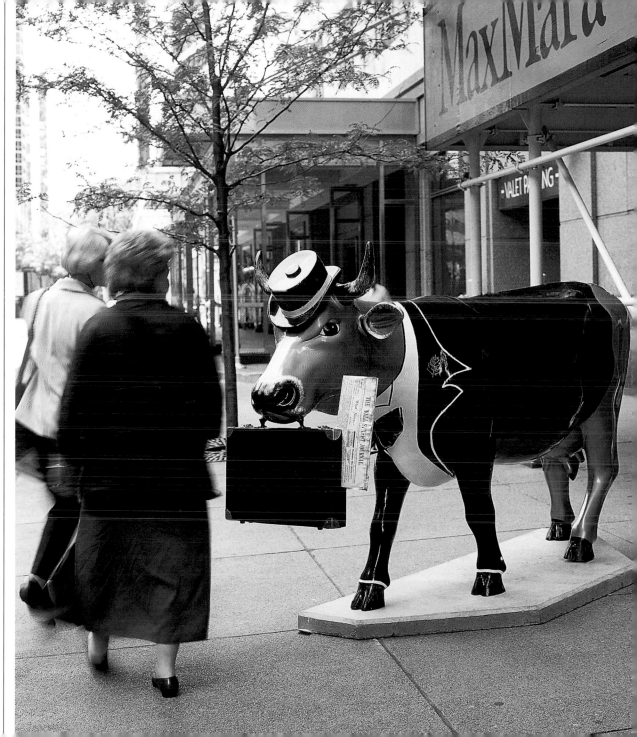

Cowccinella Novemnotata

(Nine Spotted Lady Bug Cow)
Artist: Brian Calvin
Patron: Talbott Hotel
Location: 20 E. Delaware (look up!)

C.O.W.

Artist: John Pakosta
Patron: Kimberly and Gene Foxen
Location: Michigan, Delaware to Chestnut

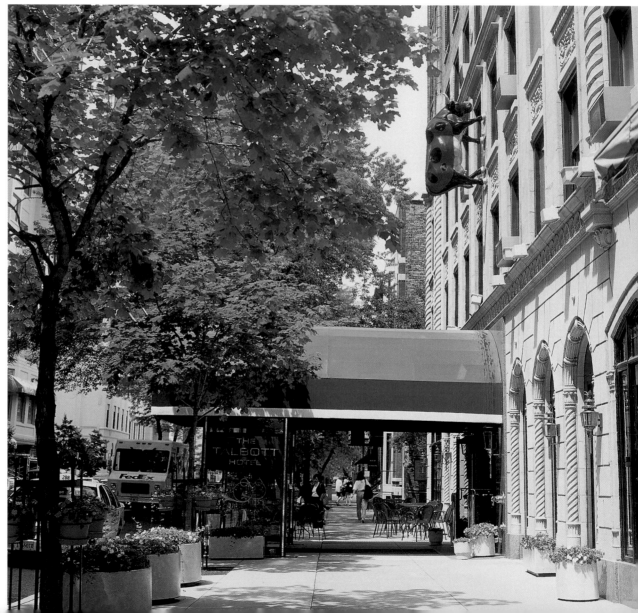

Fescue

Artist: Gina Hartig Williams
Patron: Stephanie and Bill Sick
Location: Michigan, Delaware to
Chestnut

Chicago's Landmark Cow

Artists: Maria Tubay, Flair Com-
munications with Jackie Zemke
Patron: Flair Communications
Agency, Inc.
Location: Michigan, Delaware to
Chestnut

JOHN HANCOCK CENTER

Waiter

Artist: Ken Aiken, Aardvark Studio
Patron: Signature Room
Location: 875 N. Michigan

Untitled

Artist: Students of the Ogden School
Patron: Thomas Kinkade Gallery
Location: 875 N. Michigan

F-22 Dairy Air Enforcer (USA)

Artist: Mark Nelson
Patron: ANet Internet Services
Location: 875 N. Michigan

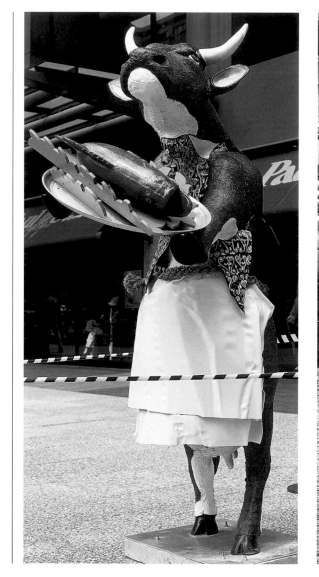

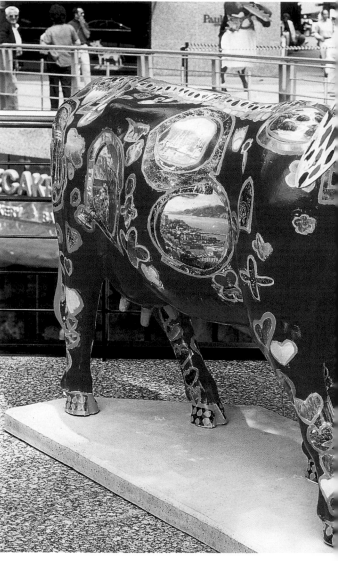

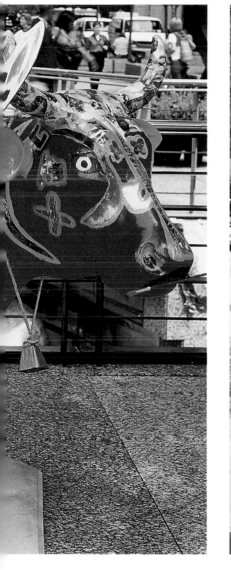

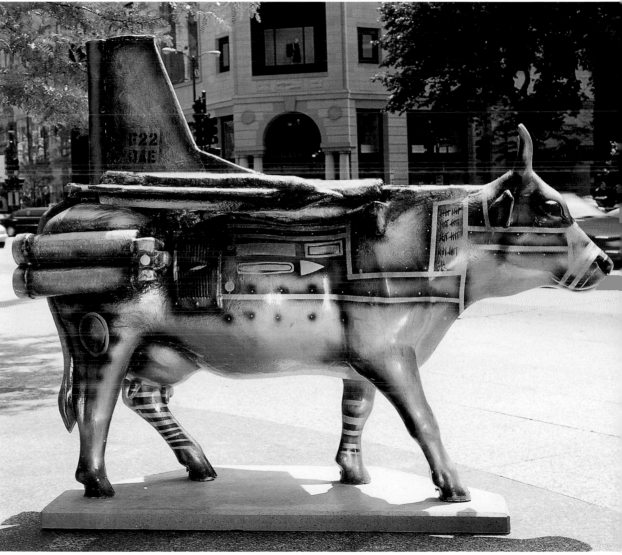

SHOPPERS AND COWS EQUALLY WELCOME

WATER TOWER PLACE

Marshall's City Cow

Artists: Students of Marshall Metro
School CYSF / Pace Partner
Patron: Water Tower Place
Location: 845 N. Michigan

Give the Lady What She Wants

Artist: Tom Bachtell
Patron:
Marshall Field's Water Tower Place
Location: 845 N. Michigan

Puttin' on the Ritz

Artist: Jim Weathers
Patron: Ritz-Carlton Hotel
Location: 845 N. Michigan Ave.,
Water Tower Place

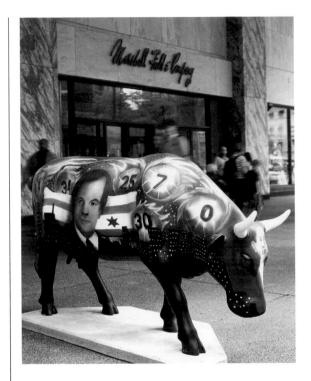

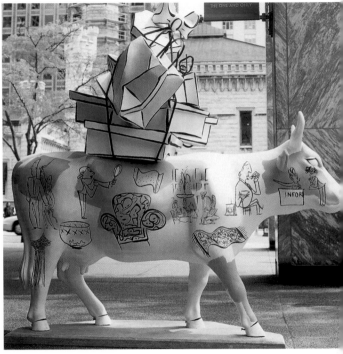

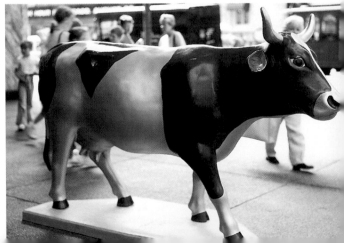

The granddaddy of vertical shopping centers, Water Tower Place was one of the first mixed-use urban shopping complexes in the country. Built in 1976, this all marble structure contains nine floors of shops and offices, a movie theater, the Ritz-Carlton Hotel and a luxury condominium tower. Greeting the shoppers at the front entrance is the «Marshall's City Cow», a collaborative effort by the students at Marshall Metro School, and artist Tom Bachtell's ode to shopping: «Give the Lady What She Wants.»

Princess Paris Pink

Story: Dena Mendes
Artist: Jim Higgins
Patron: Dena and Stephen Mendes
Location: 840 N. Michigan

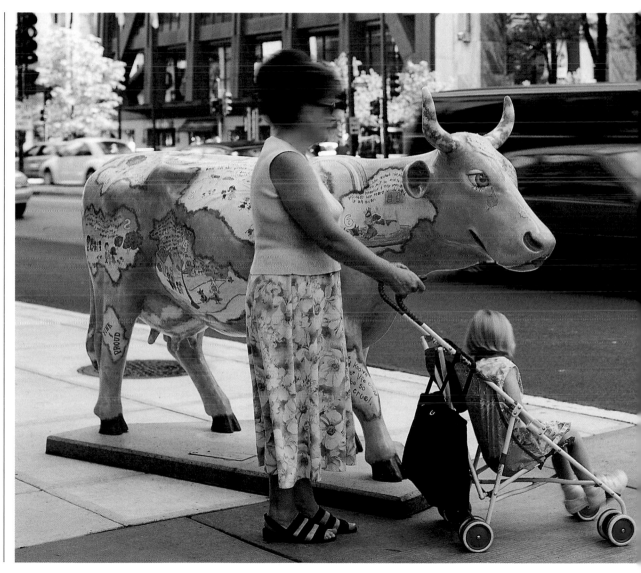

Stampede

Artist: Michael Hernandez de Luna
Patron: Ochsner International
Location: Water Tower Park

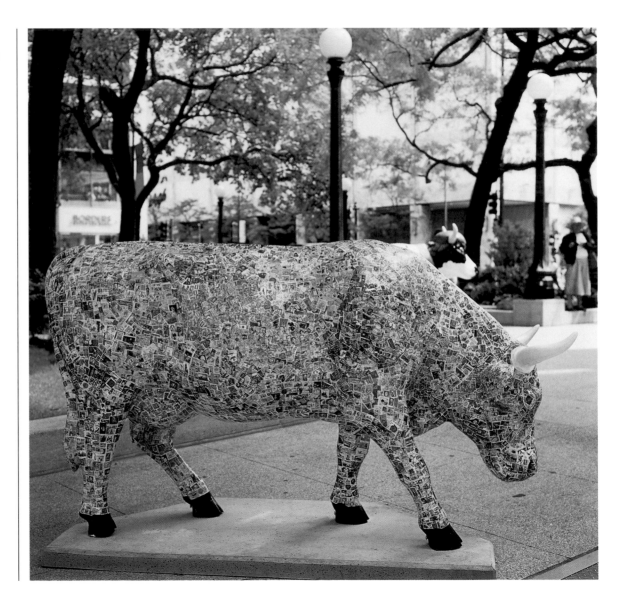

On the Mooooove

Artist: Amy Murphy
Patron: Chicago Office of Tourism
Location: 811 N. Michigan

Udder Gold

Artist: Skyline Design
Patron: Kerrygold Irish Cheese
Location: Michigan and Chicago

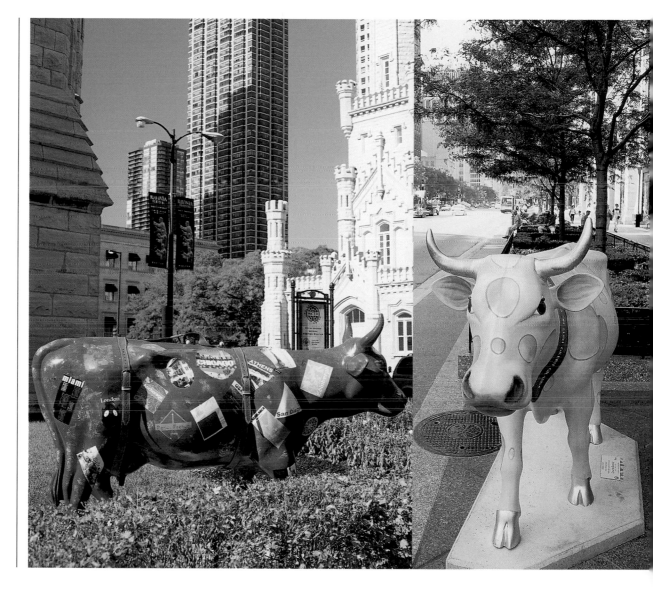

Orcow

Artist: David Buehrens
Patron: Orca Aart Gallery
Location: 806 N. Michigan

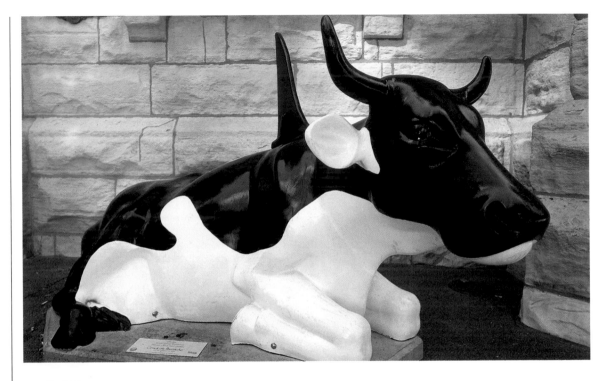

Sundae Cow

Artists: Blanca Domagalski and
Stacey Allan
Patron: DCA
Location: 163 E. Pearson

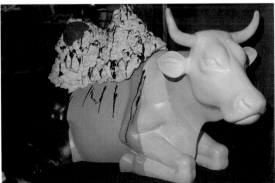

Souvenir Frenzy

The exhibit proved that cows really could fly — off the shelves and out the doors of souvenir shops. Paint-it-yourself kits of miniature cows proved particularly popular, as did cow key chains, T-shirts, baseball caps and toys. Stores report that the official «Cows on Parade» merchandise, as well as anything cow-related, have become bestsellers.

CHICAGO WATERWORKS

Moovies

Artist: Rick Paul
Patrons: Chicago International Film
Festival — Thomas Bookey, Judy and
Mickey Gaynor, Leslie Levin, Burton
Kanter, Jim Klutznick, Michael
Kutza, Jeanne Randall Malkin,
Donzell and Alisa Starks, Diane
Stilwell-Weinberg, Ana Tannen-
baum
Location: 811 N. Michigan

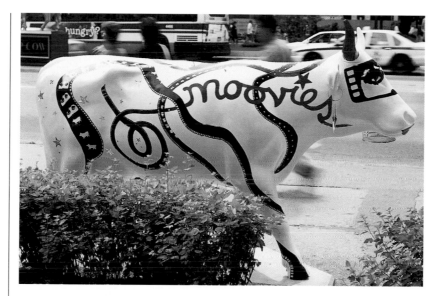

Farm in Zoo Meets Chess Pavilion

Artist: Carol A. Stitzer
Patron: Marshall Marcus,
Carol Stitzer
Location: 801 N. Michigan
(East on Chicago)

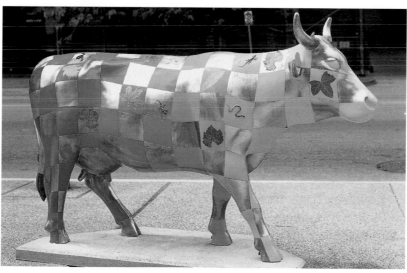

WATER TOWER PARK

The Chicago Cow Tower

Artist: Victor Skrebneski
Patron: DCA
Location: Water Tower Park

Children On Parade

Artist: Judith Raphael
Patron: Ameritech
Location: Water Tower Park

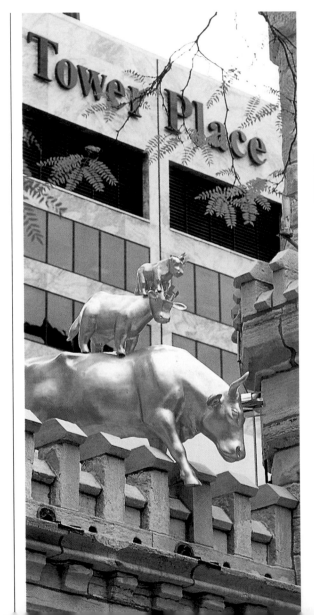

The old water tower and the pumping station across the street are the oldest buildings in the downtown area – and among the few to survive the great Chicago fire of 1871. Today, the buildings serve as visitor centers and are an excellent starting point for a self-guided cow tour.

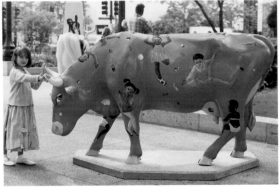

Booming Business

Retailers and restaurateurs along Michigan Avenue noted a sharp increase in revenues soon after the exhibit opened. One store alone reported a $40,000 profit over its weekly projections – attributable, staff members say, to the thousands of additional people coming down to Michigan Avenue daily to view the cows. All told, the Chicago Office of Tourism estimates that the exhibit ultimately will be responsible for generating an additional $100 million to $200 million in revenue.

O'Leary Memorial

Artist: Stephen Rybka
Patron: Victor Skrebneski
Location: Water Tower Park

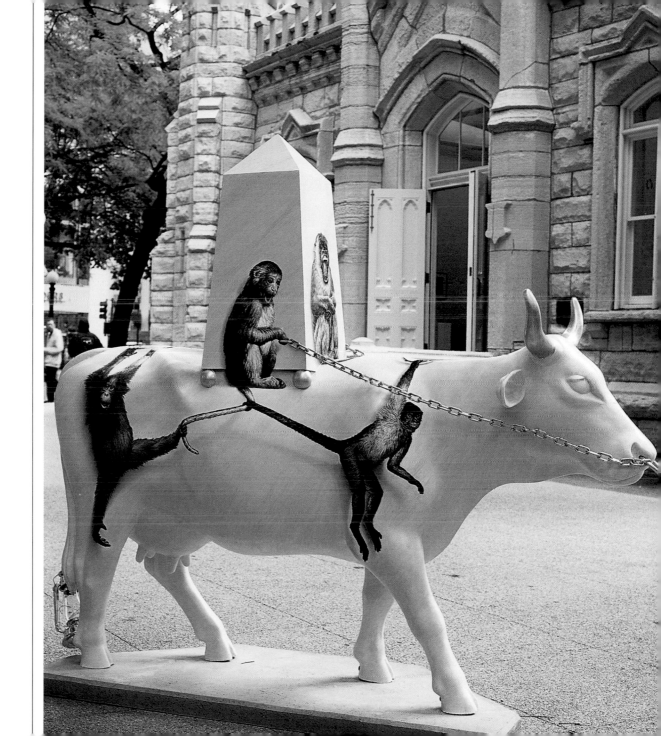

J.C. DeCow News Cow

Artist: Kozan Studios
Patron: JCDecaux USA
Location: Water Tower Park

Dairy-Go-Round

Artist: Maria Tubay, Flair Communi-
cations and Models & Props
Patron: Dairy Management, Inc.
Location: Water Tower Park

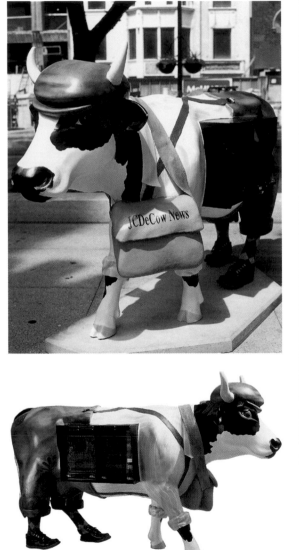

CHICAGO AVENUE

Top Cow

Artists: Stan Sczepanski,
Maria Tubay, Flair Communications
Patron: Flair Communications
Agency, Inc.
Location: Michigan Avenue Median
at Chicago

Smile, It's 2000!

Artist: David Csicsko
Patron: Jim and Barbara Hanig
Location: Seneca and Chicago,
NW corner

Don't Blame Daisy

Artist: Jennifer Graham Caswell
Patron: Margaret Graham Caswell
Location: Fire Station,
200 E. Chicago

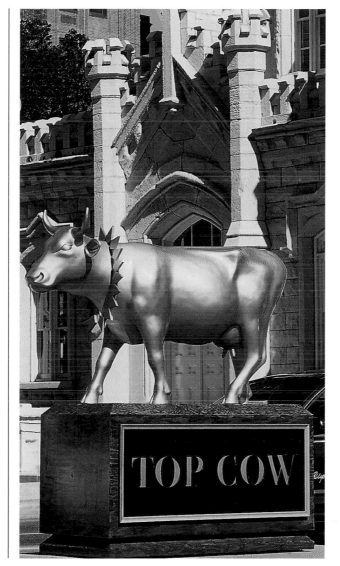

CONTEMPORARY ART MEETS COW KITSCH

**MUSEUM OF
CONTEMPORARY
ART**

Identifying

Artist: Sungmi Naylor
Patron: Museum
of Contemporary Art
Location: Museum
of Contemporary Art

Reflections

Artist: Norma Madison
Patron: Lawson House YMCA
Location: 30 W. Chicago

Mooving Eli

Artists: Becky Flory, Betty Lark Ross
Patron: Eli's Cheesecake
Location: 215 E. Chicago

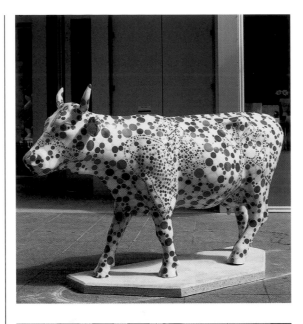

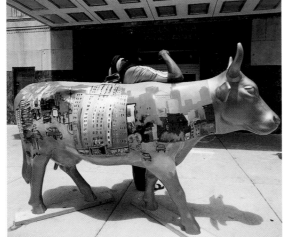

Photo Opportunities Galore

Locals and tourists alike just couldn't resist taking picture after picture of these highly photogenic bovines. There was one difference, however, between the photo habits of the Chicago native and the out-of-towner: Chicagoans tended to snap the cows in their singular splendor, while the tourists wanted their pictures taken with the cows. Regardless, a spot check of Michigan Avenue photo shops revealed that the majority of film being developed was «cows, cows and more cows.»

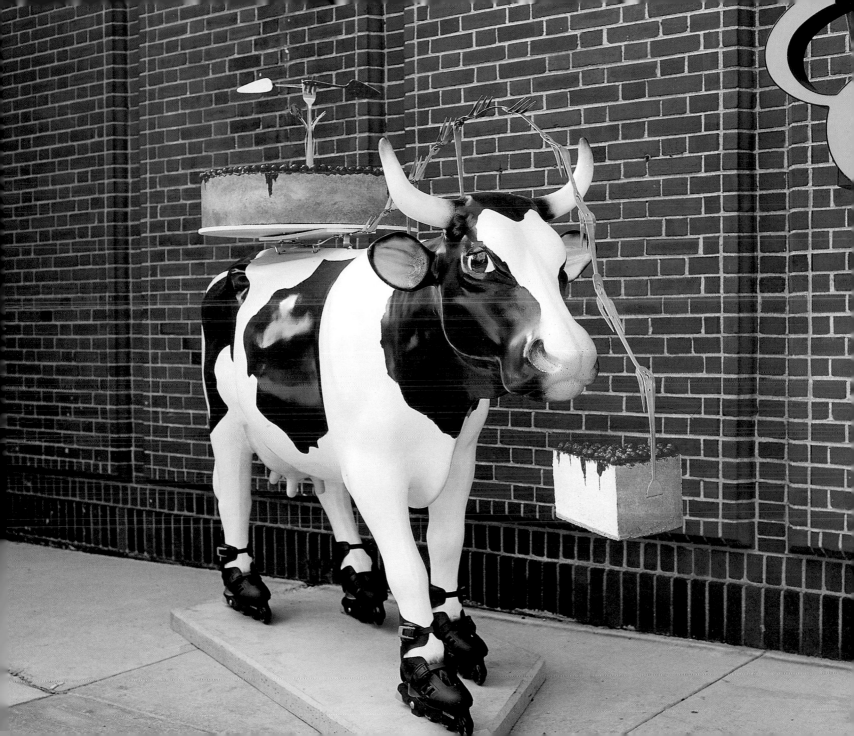

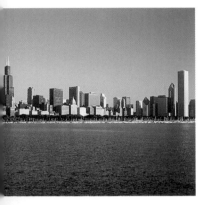

Putting the Cow in Chicago

Ever since Mrs. O'Leary's cow allegedly kicked over a lantern and started the Chicago Fire, cows have been a part of Chicago's history. Recently, the O'Leary cow received a pardon – researchers determined that the much maligned bovine didn't do it – but in a sense the tale was apocryphal. In one way or another, cows and the city of Chicago have always enjoyed a relationship, which makes the public art exhibit «Cows on Parade» all the more appropriate.

In the Beginning, There Must Have Been a Cow

No one really knows when the first cow arrived in Chicago, but long before Chicago was a city, it was part of the vast prairies of the Middle West – a landscape that a cow could easily call home. The area's first inhabitants, nonetheless, were nomadic Native Americans. Chicago's name, in fact, comes from a Native American word meaning «stinking weed» or «wild onion,» which grew plentifully on the Chicago River's swampy shores. It wasn't until 1673 that the first Europeans – French explorers Father Jacques Marquette and Louis Jolliet – arrived. Their interest lay in the river as a trade and access route, so it would be more than 125 years before the first permanent settlement was built by Jean Baptiste Point

du Sable, a French-speaking black man, who erected a cabin at the point where the Chicago River flows into Lake Michigan. It served as the region's economic hub until the U.S. government – recognizing the strategic importance of the mouth of the Chicago River – built Fort Dearborn in 1803 around where the south end of the Michigan Avenue bridge stands today.

Birth of a Cow Town

One of the youngest of the world's great cities, Chicago was incorporated as a town in 1833. In 1837, it became a city with 4,170 inhabitants. Three years later, the population grew to 30,000 residents, many of whom were speculators and entrepreneurs from the East Coast looking to make their fortunes in this frontier boom city. By 1861 – just 21 years later – as many as 300,000 people called Chicago home. Today, 2.7 million people live in the city limits, and approximately 7 million in the greater Chicago area, making it the third largest city in the United States.

The city's phenomenal growth rate has long been attributed to its transportation routes – first Lake Michigan and the Chicago River, then the railroads, and today O'Hare International Airport, the world's busiest. Back in the city's infancy, it was the Illinois Michigan canal, built in 1848, that spurred develop-

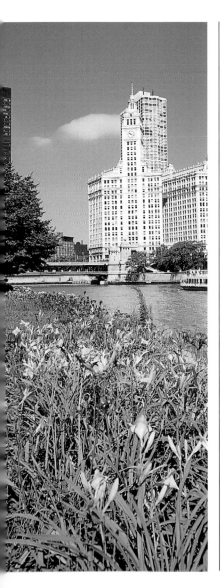

ment to new heights. Because the canal linked the Great Lakes to the Mississippi River, ships could, for the first time, travel from Buffalo to New Orleans. Chicago became both the nation's gateway to the West and a major commercial center. In addition, industry sprang up along the North Branch of the Chicago River; the two earliest facilities included a lumber mill and a meat packing plant. And where there are meat packing plants, there are cows.

«The Great Bovine City of the World»

Although Chicago's fortunes grew from grain trading and lumber, real estate speculation and rail transport, what really put Chicago on the map were its stockyards. Built in 1865 four miles south of the city on nearly a square mile of land, the great Union Stockyards held pens for 80,000 hogs, 25,000 sheep and 25,000 cattle. Not only did this make Chicago «hog butcher for the world,» as Carl Sandburg later proclaimed in his famous poem, but according to a guidebook from the 1860's, Chicago was also touted as «the great bovine city of the world» where cattle were «lodged, entertained and dispatched.»

The expansion of the rail lines and the invention of refrigerated rail cars—as well as Chicago's central location — allowed the Chicago stockyards to literally feed the nation. As a result, the city flourished, jobs multiplied, and immigrants poured in. Soon Chicago attracted a substantial Irish, German and Scandinavian population who began creating new neighborhoods on the South and West Sides — turning Chicago into the ethnic and cultural melting pot that it is today.

But Then,
Mrs. O'Leary's Cow Kicks Up Her Heels

It may not have happened according to legend — a careless cow overturning a gas lantern in a hay-filled barn — but whatever the cause, the great Chicago fire of October 8, 1871, started behind Patrick and Katherine O'Leary's house south of the city center. The summer had been unusually dry, which had turned the city of wooden buildings and plank sidewalks into a virtual tinderbox. Coupled with strong winds, the fire quickly spread out of control. It swept through the heart of the city, and when it was over, it had destroyed the commercial district, gutted most of the neighborhoods, caused more than $200 million in damage and left approximately one-third of the population homeless. The area bordered by Lake Michigan, Halsted Street, Fullerton Avenue and Roosevelt Road was little more than rubble and charred building shells. One of the few buildings left standing was the municipal water tower and pump-

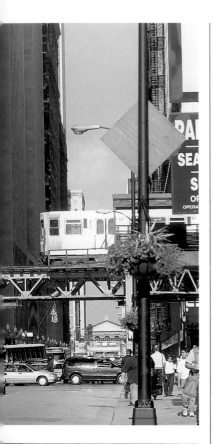

ing station, now the Michigan Avenue landmark known as the Historic Water Tower and the Chicago Water Works Visitor Center.

A Silver Lining

Refusing to be cowed, even in the face of such complete devastation, the city vowed to rebuild itself. But this time, Chicago did it a little differently. The City Council banned wooden structures in the downtown area, which led to two developments that forever influenced the shape of Chicago: It caused families of modest means to move to outlying areas where affordable wood frame houses were permitted – thus spreading out the city's population and creating many of the neighborhoods that still thrive today. And it brought a huge influx of architects and engineers to design more substantial buildings in Chicago's new city center – thus paving way for the architectural innovation characterizing modern Chicago and influencing the world's skylines for the last hundred years.

Fortunately for the city, much of its economic base – the stockyards (with all its cows!), its shipping trade, and the factories and lumber mills along the river – were out of the flames' reach, so the city had little problem finding investors for the rebuilding process. Homes and businesses went up seemingly overnight. Within a decade after the fire, Chicago

had not only reclaimed its economic place in the world, but it had become an industrial powerhouse and an urban success story.

The Golden Age

By 1893, the rising phoenix of Chicago had turned into a peacock and was ready to strut its stuff. It had its opportunity at the Columbian Exposition, the world's fair that left its more than 21 million visitors in awe of the mighty city. A giant artificial city was created in Jackson Park on the city's South Side, where pavilions and exhibition halls showcased the latest in technology, arts, sciences, agriculture, and, yes, livestock. Just 56 years after it had been incorporated as a city, Chicago had arrived.

During the decades that bracketed the turn of the century, Chicago could boast the largest unified street railway system in the world and the nation's first elevated train – the famous «L» that still exists today encircling the commercial center, creating the «Loop.» Daily these elevated trains poured ¾ million commuters into downtown. As the heart of Chicago, the Loop provided a wealth of services concentrated in an area less than a square mile, unheard of for a city its size. «State Street, that great street» became the shopping mecca, anchored by rival department stores Marshall Field's and

Carson, Pirie Scott. Randolph Street held a theater district. South State Street teemed with penny arcades and burlesque palaces. LaSalle Street was lined with banks, law firms and financial instituti- ons, including the Board of Trade, which led the nation in grain trading. Wholesale produce markets flourished on South Water Street. A new City Hall and other government buildings dominated Clark Street. The Coliseum on South Wabash hosted poli- tical conventions and became home to Chicago's distinctive brand of rough-and-tumble politics. And Michigan Avenue, just east of the Loop, offered elegant shops, book stores, the public library and cultural institutions.

Outside the city center, industry grew. Cows were still important – the stockyards and meat packing plants remained strong – but Chicago's economic base spread out. Giant steel and iron works moved in, agricultural companies blossomed and factories took root. Chicago produced 18% of all the country's men's clothing and was second only to New York in printing and publishing. It was during this era, not surprisingly, that Chicago's reputation as a sprawl- ing and brawling city of big shoulders was forged. As one city boss from the notorious First Ward put it, «Chicago ain't no sissy town.»

But it wasn't all muscle and hustle either. Chicago grew up in the hands of some very capable archi- tects and city planners. By 1889, voters living in the surrounding 120 square miles had elected to join the city, bringing the total area of Chicago to 185 square miles and its population over the million mark. Some proper city planning was in order, and Daniel H. Burnham was the man for the job. This architect and urban planner, whose vision of the city is respon- sible for much of how Chicago looks today, crafted his Plan of Chicago in 1909, which, among other things, created the grand boulevard system, the 29 miles of lakefront parks, and the forest preserves encircling the city. His blueprint casts a long shadow on the city even today and has been considered the most influential urban planning document of the modern world.

A City of Neighborhoods

With Chicago's industrial and economic growth came jobs. People streamed into the city in unpre- cedented numbers. African-Americans migrated up from the South and put down roots on the South Side. Immigrants crossed the ocean to start new lives in America's second-largest city. By 1890, 78% of Chicago's population was either foreign-born or children of the foreign-born. Greeks, Bohemians, Italians, Mexicans, Poles, Eastern European Jews, Ukrainians, Chinese and many other groups who emigrated began carving out their own neighbor- hoods across the city. While today many of the

divisions that once segregated neighborhoods have disappeared – due to population shifts, gentrification and more tolerant racial attitudes – the majority of Chicago's 77 neighborhoods still retain the distinct influence of the original group that settled it.

The City that Works

In the period between 1920 and 1970, which included the Great Depression, World War II and the postwar boom years, Chicago's development more or less mirrored the rest of the country's. The factors shaping America also affected Chicago: The rise of the car culture, the exodus to the suburbs, the decline in manufacturing and industry within city limits, racial discord, student unrest, changing family structure. The Loop lost its prominence, and for a while, people talked about the «death of the city.» But obviously they didn't know Richard J. Daley, Chicago's longtime love-him-or-hate-him mayor, first elected in 1955. As head of what was commonly known as the Democratic political «machine,» Daley made Chicago work in ways that few cities in the nation could. Fiercely devoted to Chicago, Daley initiated massive public works and urban renewal projects, built expressways and schools, courted management and labor alike, supported business development and paved the way for new construc-

tion – creating much of the infrastructure that still sustains the city. Sad to say, cows played little part in this period of Chicago history. The stockyards closed for good in 1971, and, for a time, the only place to find cows in Chicago was in the cattle trading pit at the Mercantile Exchange.

The Running of the Bulls

The go go years of the '80s saw Chicago prosper. New buildings went up, unemployment went down, and people started moving back into the city. Michigan Avenue's Magnificent Mile attracted luxury stores, young professionals rehabbed forgotten neighborhoods, theater companies popped up all over the city, outdoor concerts and street festivals entertained residents all summer, and new businesses pumped money into the economy. But by the early '90s, the one thing that made Chicago a household name worldwide was its professional basketball team, the Chicago Bulls. Led by superstar Michael Jordan, the Bulls won six championships and held the city in its thrall. So universal was the team's appeal, that when Chicagoans traveled abroad, instead of being met with the pantomimed rat-a-tat-tat of Al Capone's machine gun they, instead, heard, «Go Chicago Bulls! Go Michael Jordan!» Once again, cows – well, at least a variation of them – make their mark on Chicago.

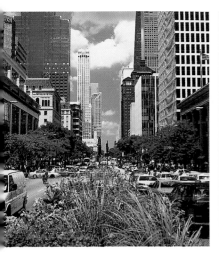

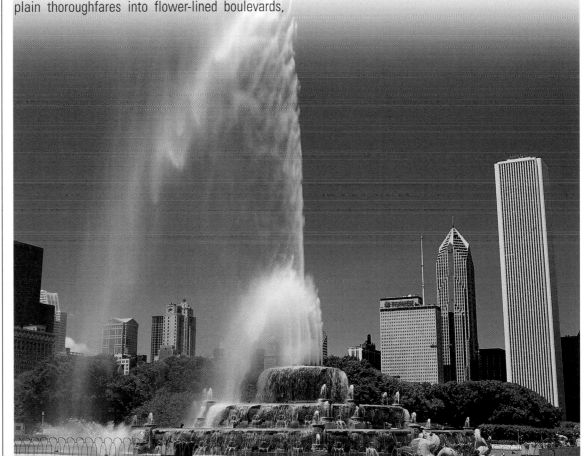

The Son Also Rises and the Cows Come Home

Today, with Mayor Daley's son, Richard M. Daley, at the helm, Chicago has matured into a different kind of city. While still strong and tough at its core, it's a little softer around the edges. The new Mayor Daley has embarked on an ambitious beautification program that has planted thousands of trees, turned plain thoroughfares into flower-lined boulevards, restored bridges, built parks, created bike paths, and installed ornamental touches to common streetlights, signposts and park benches. The business community continues to prosper, the downtown area has become a rich cultural mecca, the Loop pulses with new energy, and art programs big and small thrive. It's no wonder the cows came home. Chicago's their kind of town.

Visual Cacophony in 6 Movements

Artist: Kermit Berg
Patron: Chicago Transit Authority
Location: 736 N. Michigan

Cowiggy Bank

Artist: Dennis Callahan
Patron: Banco Popular
Location: Superior and Michigan
(SE corner)

AN URBAN PASTURE

MICHIGAN AVENUE
(Chicago Avenue to the River)

Moo Blue Cow

Artist: George Rodrigue
Patron: Neiman Marcus
Location: 737 N. Michigan at
Superior

Grazing with the Cows

Artist: George Rodrigue
Patron: Neiman Marcus
Location: 737 N. Michigan at
Superior

Black Tie Dogs

Artist: George Rodrigue
Patron: Neiman Marcus
Location 737 N. Michigan at
Superior

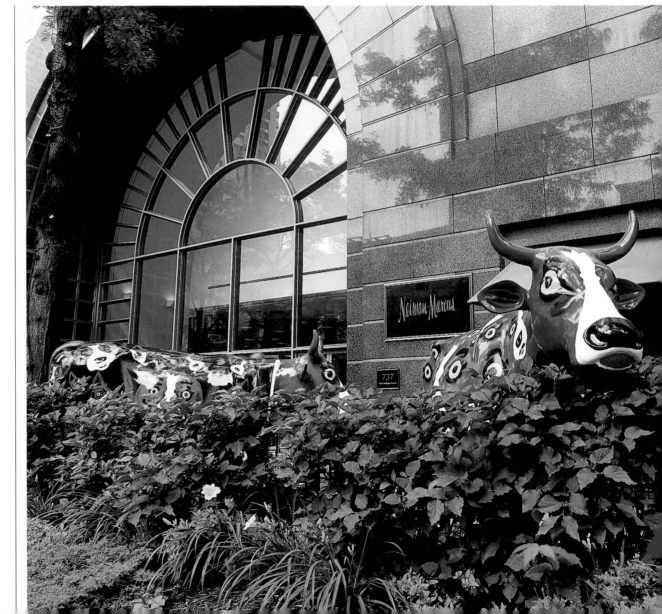

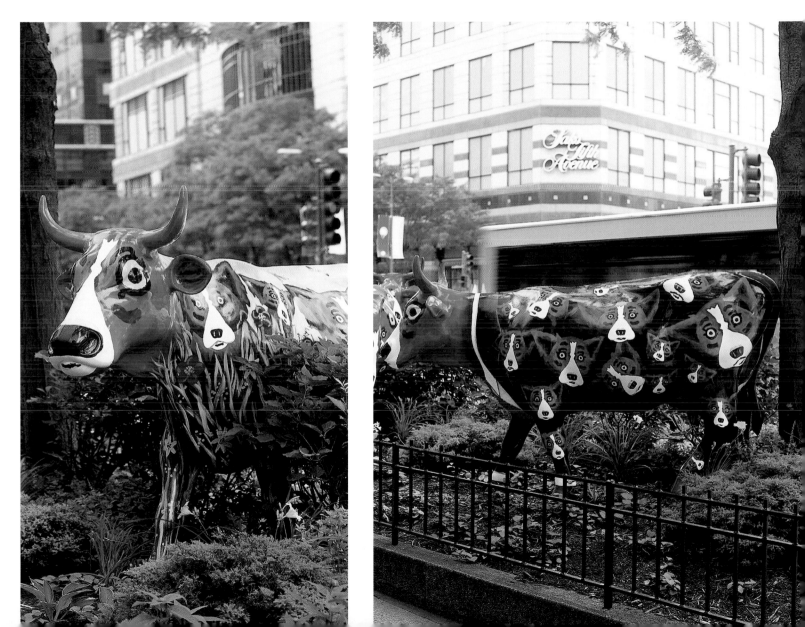

Got Pizza

Artist: John Thoeming
Patron: Gino's East of Chicago,
The Original
Location: 160 E. Superior, east of
Michigan

Cowiggy Bank

Artist: Dennis Callahan
Patron: Banco Popular
Location: Superior and Michigan,
SE corner

Blue Is the Color of My Dreams

Artist: Dennis Callahan
Patron: Tiffany & Co.
Location: 730 N. Michigan at
Superior

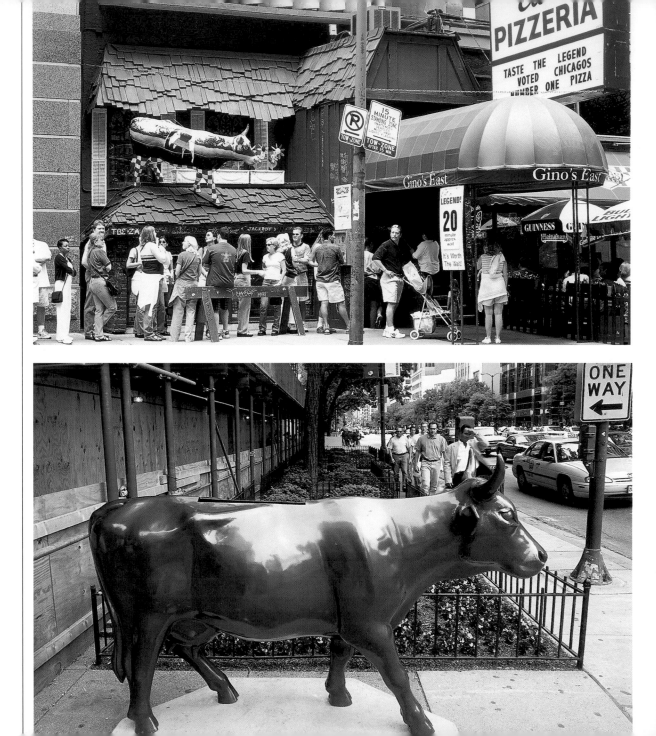

Colonized Bovine

Artist: Adam Brooks
Patron: Saks Fifth Avenue
Location: Superior and Michigan,
SW corner

Unbridling Beatrix

Artist: Shari Swartz
Patron: Allerton Crowne Plaza Hotel
Location: 701 N. Michigan on Huron

Untitled

Artists: Vince Darmody/
Michael Langlois
Patron: Dr. Martens
Location: Michigan and Huron
Median

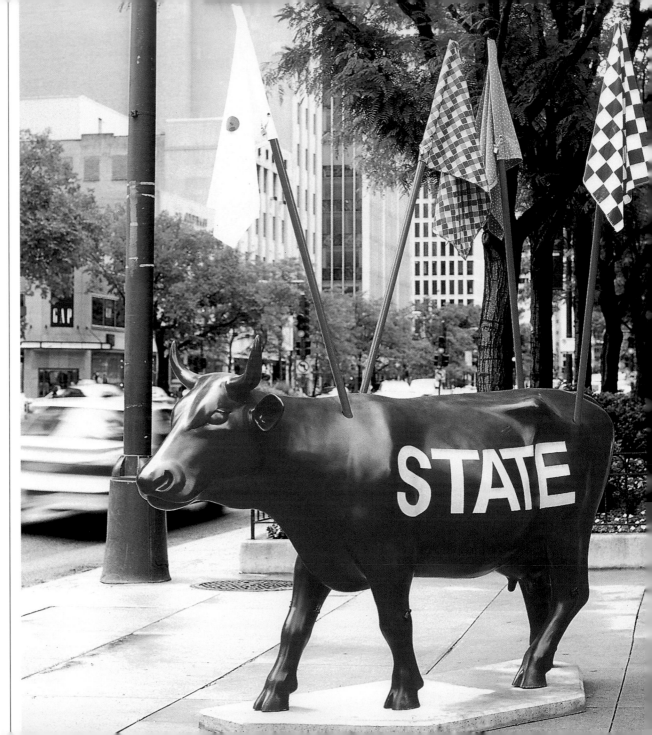

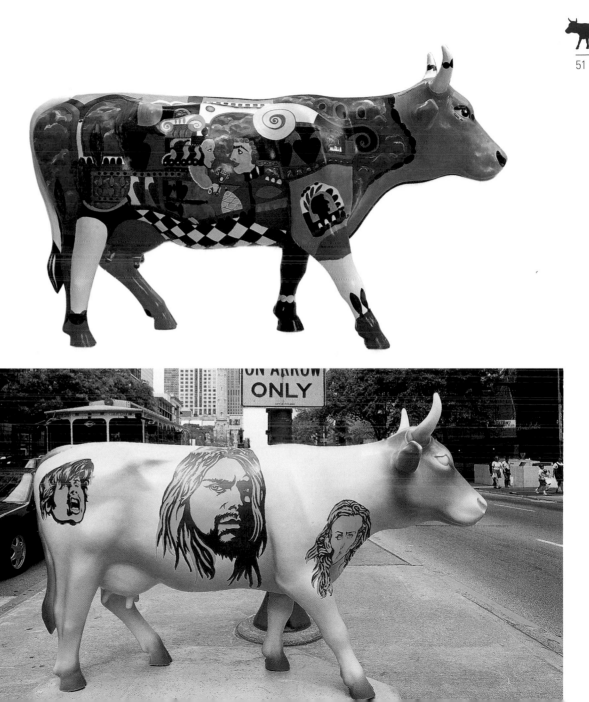

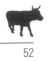

JUST PART OF THE SCENERY ...

Rick's Joy

Artist: Maryanne Warton
Patron: Corrugated Supplies Corp.
Location: 700 N. Michigan at Huron

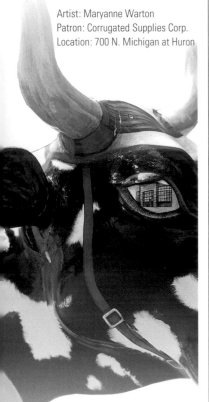

Planet Chicowgo

Artist: Lois Hrejsa
Patron: Days Inn Lincoln Park North
Location: 679 N. Michigan at Huron

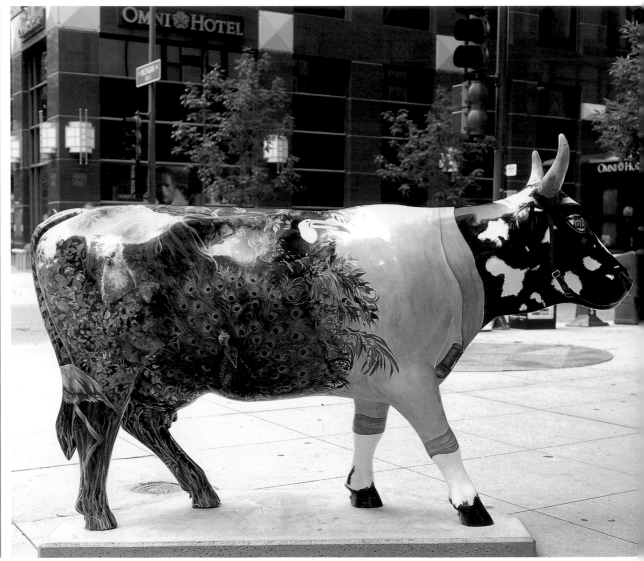

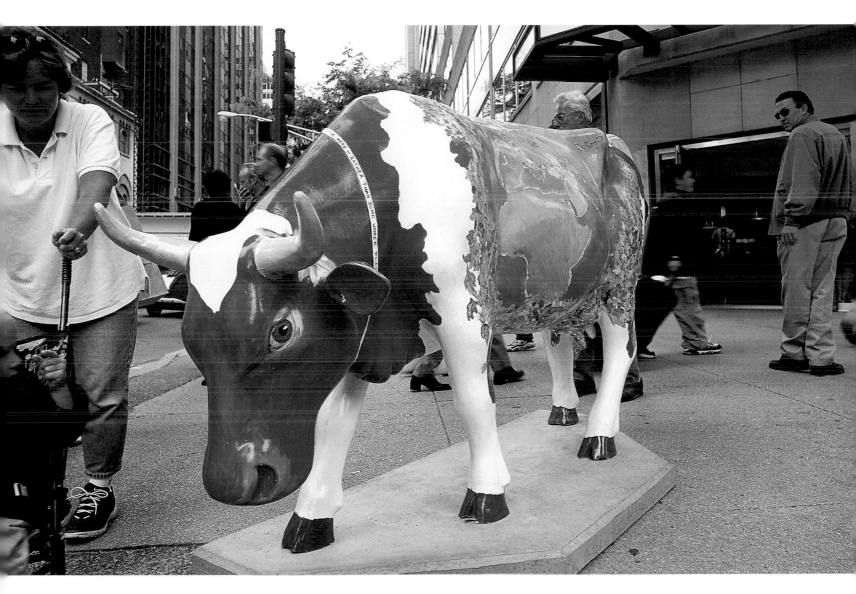

TERRA MUSEUM

Spring Flowers

Artist: Terra Museum of
American Art, Education Staff
Patron:
Terra Museum of American Art
Location: 664 N. Michigan

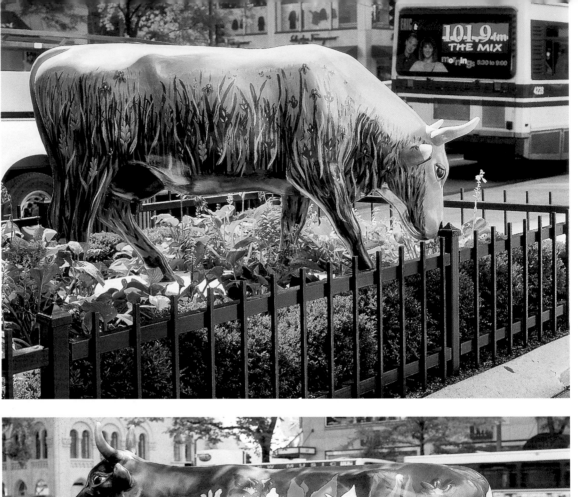

Cow in a Garden

Artist: Terra Museum of
American Art, Education Staff
Patron:
Terra Museum of American Art
Location: 664 N. Michigan

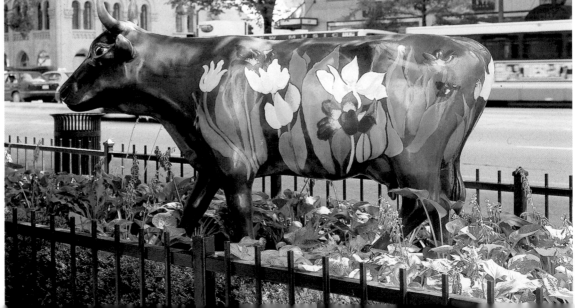

Angel Cow

Artists: Children of Lawrence Hall
Patron: Bays English Muffins
Location: 65 E. Huron

Virtual Cow in Reflective Moosaic

Artist: SouthWest Graphics and
Disney Imagineering
Patron: Disney Quest
Location:
Ohio and Rush (SW corner)

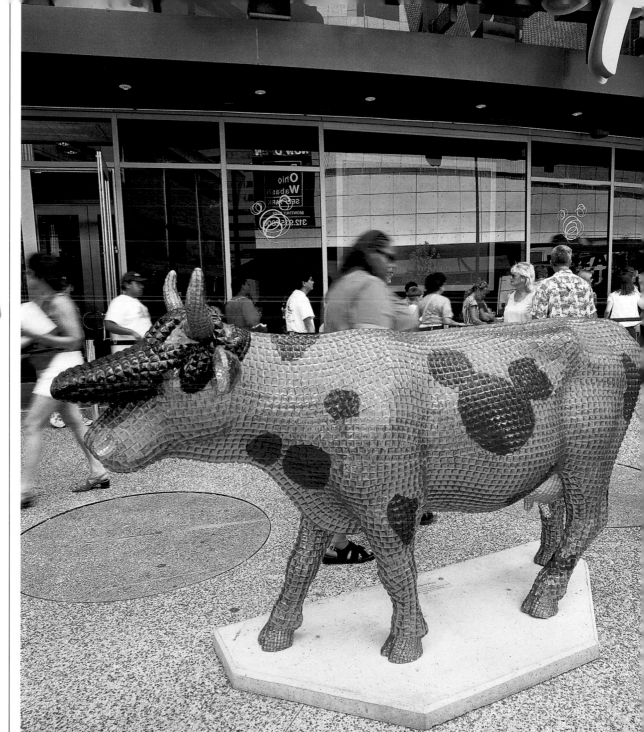

TURNING IDEAS ABOUT ART UPSIDE DOWN

Construction Cow

Artist: Jennifer Steinman
Patron: James McHugh
Construction
Location: 663 N. Michgan

Spot and Line Composition

Artist: Chris Hill
Patron: Hanig's Footwear
Location: 660 N. Michigan at Erie

Odalisque

(Reclining Nude)
Artist: Mike Baur
Patron: Maude Hanig
Location: 660 N. Michigan at Erie

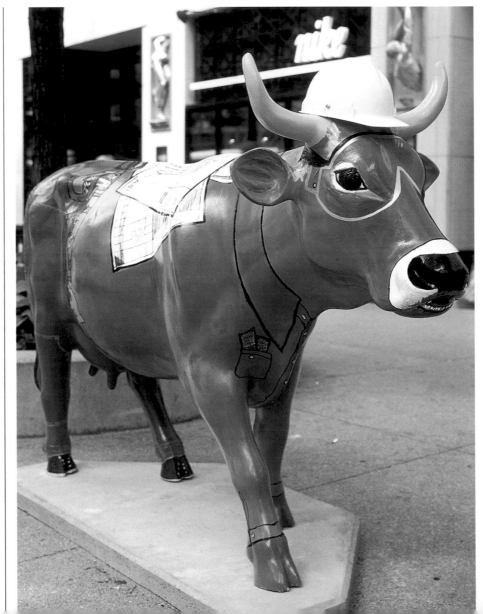

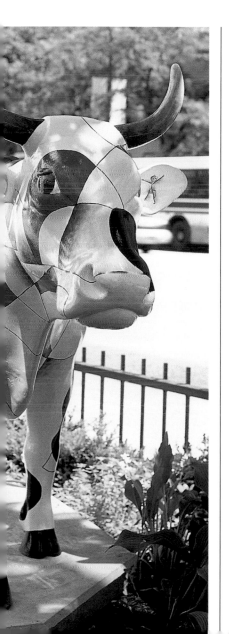

SIMPLY DIVINE BOVINES

Mirroriam

Artist: Jeffrey J. Conroy
Patron: Foote, Cone & Belding
Location: Michigan at Erie,
SW corner

Mosaic Cow:
Ancora Marco Pizzato "Cora Cow"

Artists: Julie Angio, Clayton Dibble,
Julie Schumacher, Anita Burg
Patron: Crate & Barrel
Location: 646 N. Michigan

Incowgnito

Artist: Joyce Elias
Patron: Golub & Company
Location: 625 N. Michigan

Moo-chos Colores

Artist: Susan Spitzer-Cohn
Patron:
Donald and Susan Spitzer-Cohn
Location: 602 N. Michigan

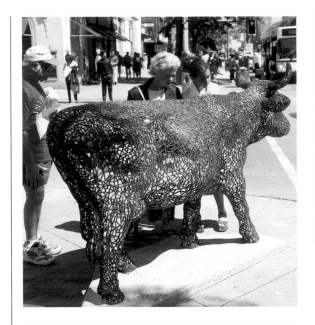

Diamonds Are A Cow's Best Friend

Artist: Victor Skrebneski
Patron: Salvatore Ferragamo
Location: 645 N. Michigan at Erie

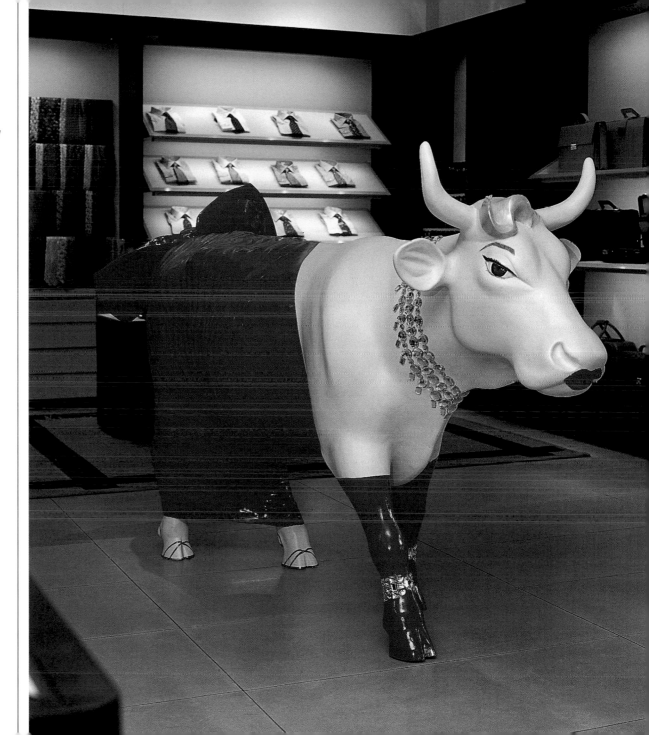

Mock Turtle

Artist: Jethro Fisher
Patron: Turtle Wax
Location: 600 N. Michigan

Ushi

Artists: Jill Henry with Lori Schmidt
and Tanya Howard
Patron: Clarence Davids & Co.
Location: Michigan Avenue Median
at Ohio

Are they or aren't they? That's the question frequently asked when the gender of Chicago's art cows comes under scrutiny. Their prominent udders reveal them to be female, but what about those horns? Chicagoans familiar with the Bulls' logo associate the presence of horns with bovines of the male persuasion — so how come the parading cows sport both? The answer lies across the ocean, where the original molds for the fiberglass cows were first cast. Modeled after the brown milking cows that graze on Switzerland's alpine meadows, these cows have both horns and udders, something that, incidentally, all cows — whether U.S. or Swiss — are born with. In the United States, however, most cows are de-horned at a young age, whereas in Switzerland they keep their horns for a lifetime. The folks running the Chicago show looked into creating cows that more closely resemble the American dairy cows people are familiar with, but in the interest in time, they opted to import the same models used in the Zurich show. There are three variations of these cows — standing, grazing and reclining — but rest assured, all are udderly female.

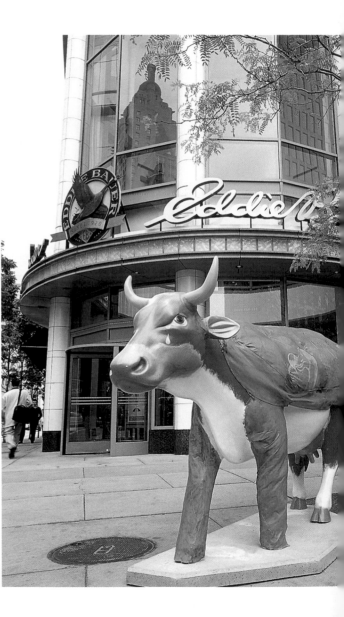

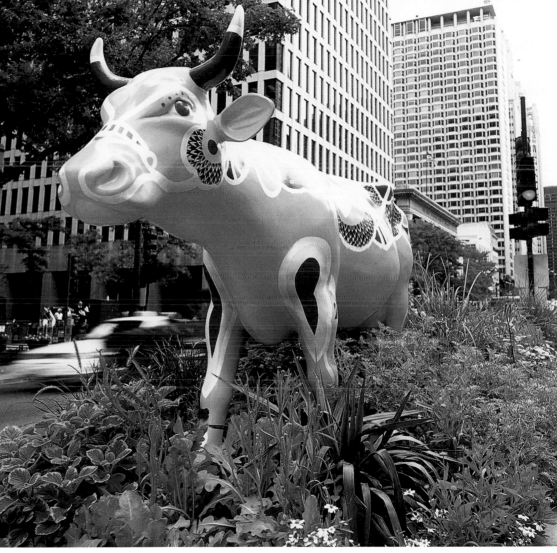

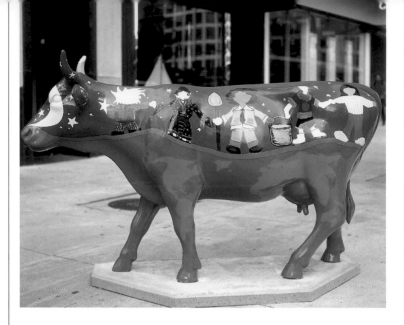

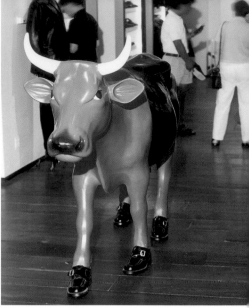

PeaceLand

Artists: Chelsea Badeau and
Elizabeth D'Andrea
Patron: The Timberland Company
Location: 543 N. Michigan at Ohio

Untitled

Artist: Mike Banicki
Patron: Florsheim Shoes
Location: 605 N. Michigan at Ohio

Cowshoes

Artist: Dennis Callahan
Patron: Kenneth Cole
Location: 540 N. Michigan

Shoe Horn

Artist: Christopher Tuscan
Patron: Allen Edmonds Shoes
Location: 541 N. Michigan

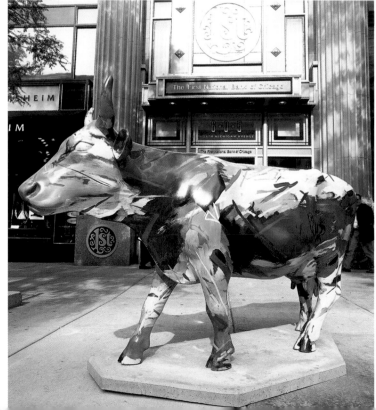

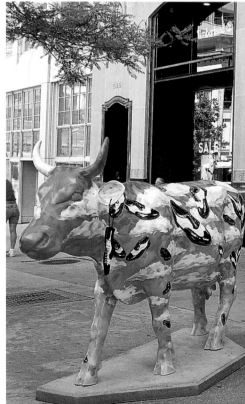

I Did Not Start the Chicago Fire

Artist: Mr. Imagination
Patron: House of Blues
Location: 540 N. Michigan

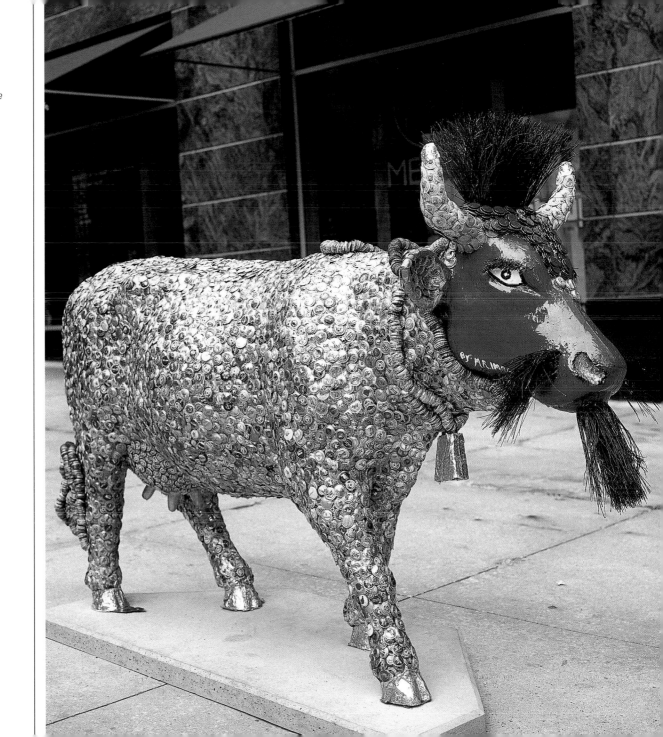

Collage Cow

Artist: Juan Chavez
Patron: John Buck Company
Location: 520 N. Michigan
(on the barricade)

Cow in Progress

Artists: Jeannie Lukow,
Tammy Bagolin, Kerrie Walsh,
Donna McCormick, Cheryl Neufedt,
Cristine Drover and Terry McDemott
Patron:
National Association of Realtors
Location: 420 N. Michigan

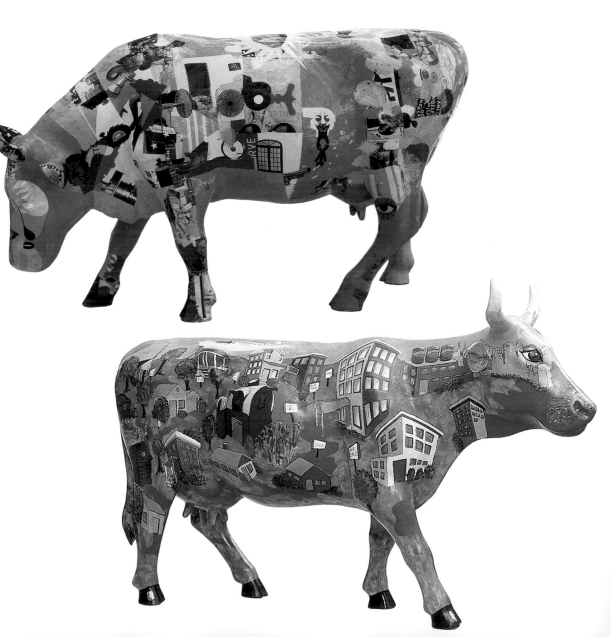

The Milky Way

Artist: Lorri Gunn
Patron: John Buck Company
Location: 520 N. Michigan
(on the barricade)

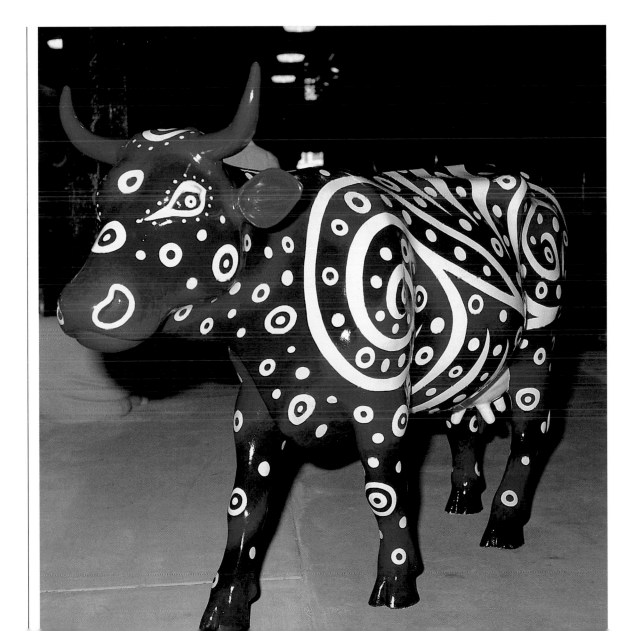

Udder, Mudder Earth

Artist: Constance Lee Trojnar
Patron: Earth Works Gallery at
Avenue Business Center
Location: 500 N. Michigan

Inter-Continental Orbiter

Artist: Maria Odilia Allwicher
Patron: Inter-Continental Hotel
Chicago
Location: 505 N. Michigan at Grand

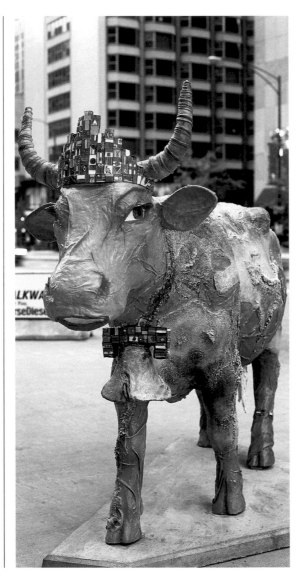

Earth Mother Created

In many cultures, the cow is a symbol of fertility, motherhood and nourishment. By overlaying a topographic world map on the cow form, artist Constance Trojnar has created the ultimate earth mother.

A Local Legend Reincarnated

The cow at right commemorates beloved sportscaster and number-one Chicago Cubs baseball fan Harry Caray, who died in early 1998. Harry Caray was most well-known throughout the city for two things: the expression «Holy Cow!» which he shouted whenever the Cubs got a hit or made an outstanding play, and his trademark oversized black frame glasses.

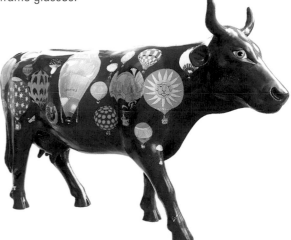

PIONEER COURT

Holy Cow!

Artist: Ken Aiken, Aardvark Studio
Patron: Harry Caray's Restaurant
Location: 435 N. Michigan

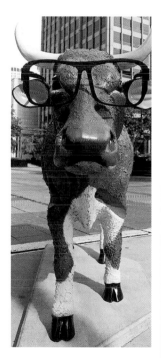

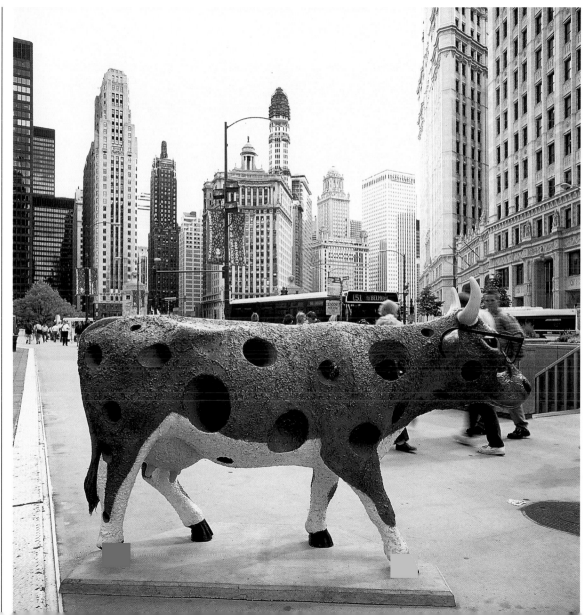

Site-specific Cow

Artist: Edra Soto Fernandez
Patron: The Equitable Life Assu-
rance Society of the United States
Location: 401 N. Michigan

Herd Instinct

Artist: Kathryn Trumbull Fimreite
Patron: The Equitable Life Assuran-
ce Society of the United States
Location: 401 N. Michigan

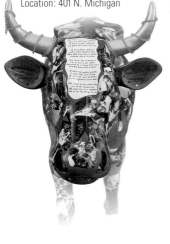

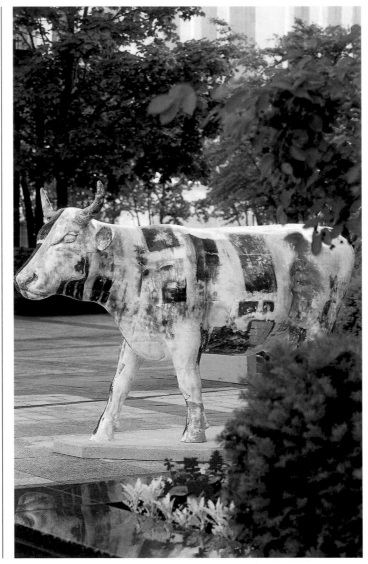

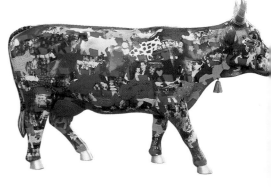

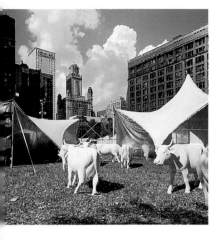

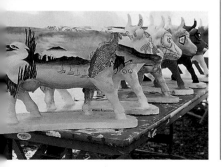

For many working artists, participating in a show the size of «Cows on Parade» is a good career move – giving them the opportunity to display their work to an unprecedented number of viewers, many of whom are not regular museum- or gallery-goers. But for up-and-coming student artists, «Cows on Parade» could be a career-maker – giving them the break they need to turn an adolescent passion into a lifelong occupation.

The beauty of «Cows on Parade» is that as an un-juried show, it welcomed artists of all levels – making it possible for first-time exhibitors to share the spotlight with such internationally acclaimed artists as Ed Paschke and Karl Wirsum. Two patrons in particular opened doors for fledging artists. The Equitable Life Assurance Society of the United States created a contest for students of The School of the Art Institute of Chicago to design the five cows it sponsored. And Gallery 37, the city's award-winning job training program in the arts created by the Department of Cultural Affairs, acquired 20 to 25 cows for its apprentices – mostly high school students – to design. Their cows are pictured at left.

Many other organizations made it possible for students to take their first step into the art world: Robert Morris College sponsored two cows for its art and design students; the Thomas Kinkade Gallery sponsored one for the students of the Ogden School, and Water Tower Place sponsored one for students of Marshall Metro School. The Chicago Academy for the Arts, a high school with an arts based curriculum, created four cows, thanks to the owners of 205 and 225 N. Michigan Avenue. Hilton Chicago and Towers organized a competition among young artists at the Doolittle Middle School. The Evans Food Products Company called on the Yollocalli Youth Museum apprentice artists to transform its cow into art. The Swiss Businesses from the Suburbs group sponsored a cow for the children of Issac Fox School; the Bays English Muffin Corporation bought a cow for the children of Lawrence Hall; and the Department of Planning and Development purchased a cow for the After School Program of the Back of the Yards Council to be located at the site of the historic stockyards. And three sponsors – United Airlines, Kenneth Cole and Children's Memorial Hospital – found a way to do a little casual mentoring by pairing artists with children to jointly create their cows.

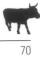

PIONEER COURT

Kevlar Cow

Artist: Stacey Allan
Patron: The Equitable Life Assurance Society of the United States
Location: 401 N. Michigan

Hawaiian Cow

Artist: United Airlines Creative Services and Gallery 37
Patron: United Airlines
Location: 401 N. Michigan

This Is Not a Cow

Artist: Thomas P. Jacobs
Patron: The Equitable Life Assurance Society of the United States
Location: 401 N. Michigan

London Cow

Artist: United Airlines Creative Services and James Jordan Boys & Girls Club
Patron: United Airlines
Location: 401 N. Michigan

Suit

Artist: Zachary Stadel
Patron: The Equitable Life Assurance Society of the United States
Location: 401 N. Michigan

Market Moo Cow

Artist: Lohan Associates,
Sarah Bader
Patron: University of Chicago
Graduate School of Business
Location: 401 N. Michigan

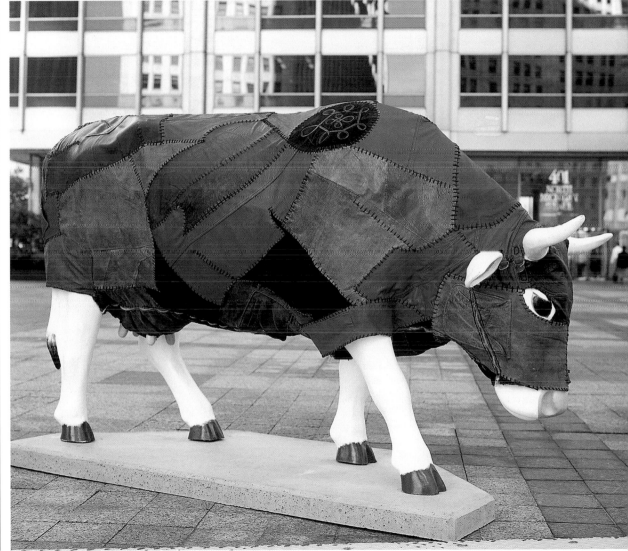

A HERD GATHERS AT A FAMILIAR CHICAGO LANDMARK

WRIGLEY BUILDING

Juicy Jammer

Artist: Peter Van Vliet, Lou Beres & Associates
Patron: Wm. Wrigley Jr. Company
Location: 400–410 N. Michigan

Winter Wondercow

Artist: Peter Van Vliet, Lou Beres & Associates
Patron: Wm. Wrigley Jr. Company
Location: 400–410 N. Michigan

Udder Romance

Artist: Peter Van Vliet, Lou Beres & Associates
Patron: Wm. Wrigley Jr. Company
Location: 400–410 N. Michigan

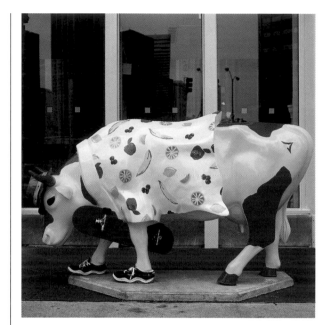

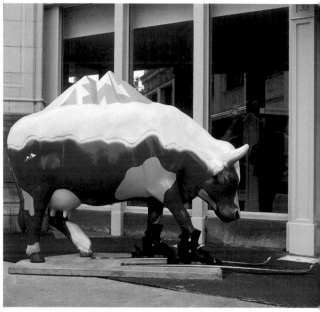

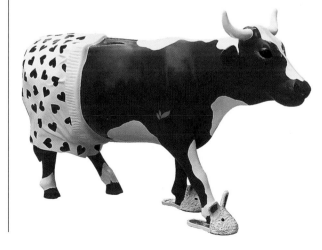

The Chicago skyline wouldn't be complete without the gleaming white terra cotta Wrigley Building, built in the early '20s by the family of chewing gum fame. With its baroque ornamentation, filigree clock tower and brightly lit facade, it stands along the northern edge of the Chicago river as a reminder of how Chicago looked before it became the «City of Big Shoulders».

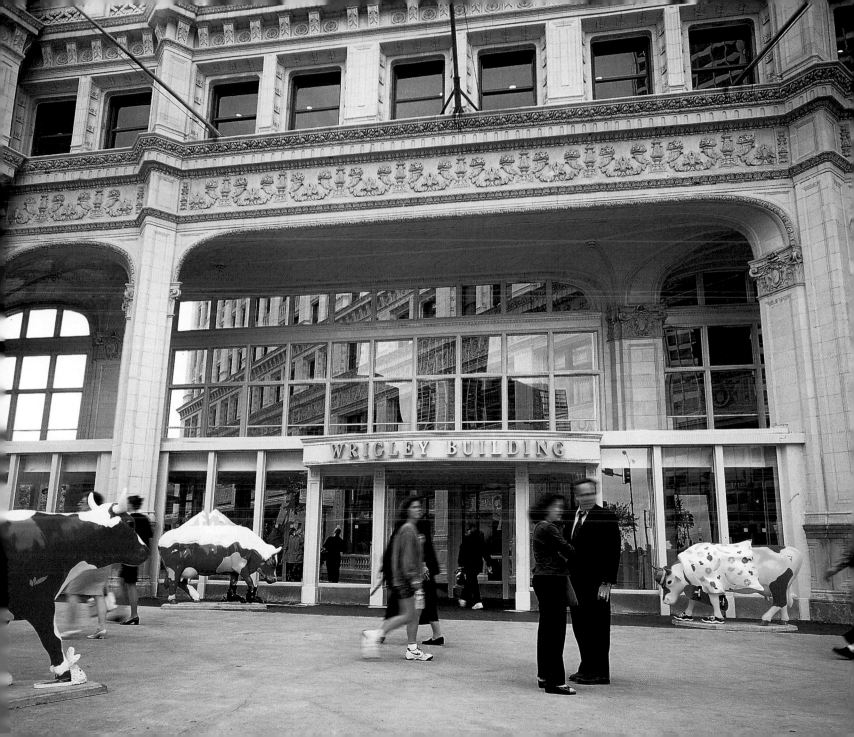

Cow «Udder» Construction

Artist:
Koglin – Wilson Architects, Inc.
Patron: Ragnar Benson Inc.
Location: 400–410 N. Michigan

Taurus

Artist: Donald Stahlke
Patron: Block Electric Company
Location: 400–410 N. Michigan

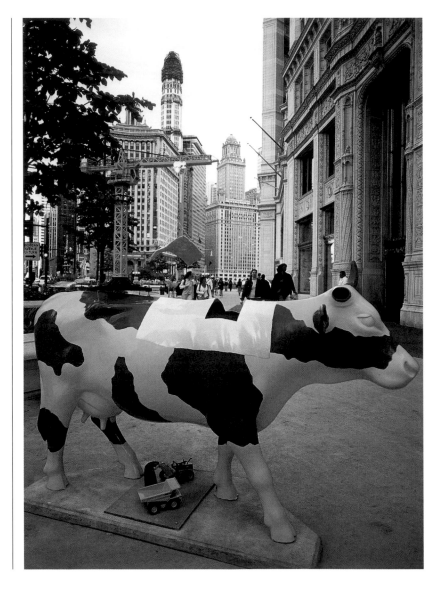

DoubleMoo

Artist: Peter Van Vliet, Lou Beres &
Associates
Patron: Wm. Wrigley Jr. Company
Location: 400–410 N. Michigan

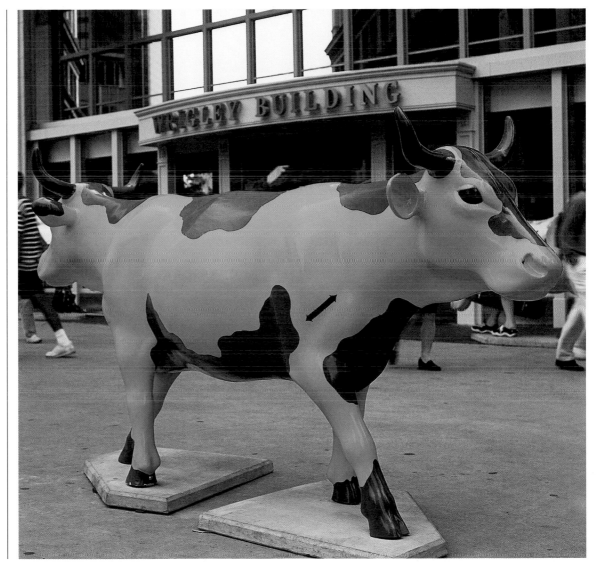

FEATS OF ENGINEERING AND ARTISTRY

Hey-diddle-diddle

Artists: William McBride with
Pat Moss and Michael Stack
Patron: McBride & Kelley Architects
Location: 400–410 N. Michigan

Moollennium

Artist: Peter Bucks
Patron: Clune Construction
Company
Location: 400–410 N. Michigan

LC1

Artist: David Innes
Patron: BBDO – Chicago
Location: 400–410 N. Michigan

Out of Cowtowner

Artists: Manley Armstrong and
Caren Spigland
Patron: BBDO – Chicago
Location: 400–410 N. Michigan

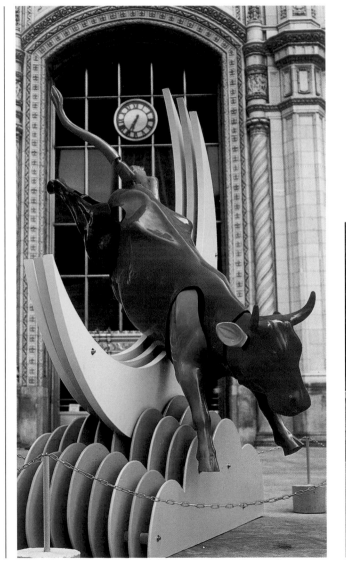

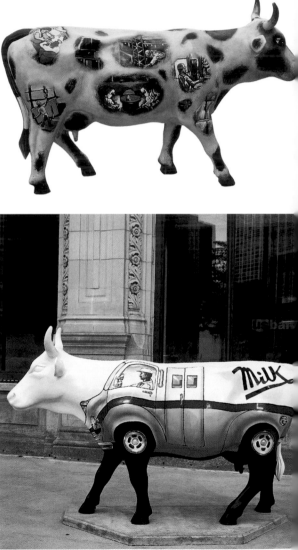

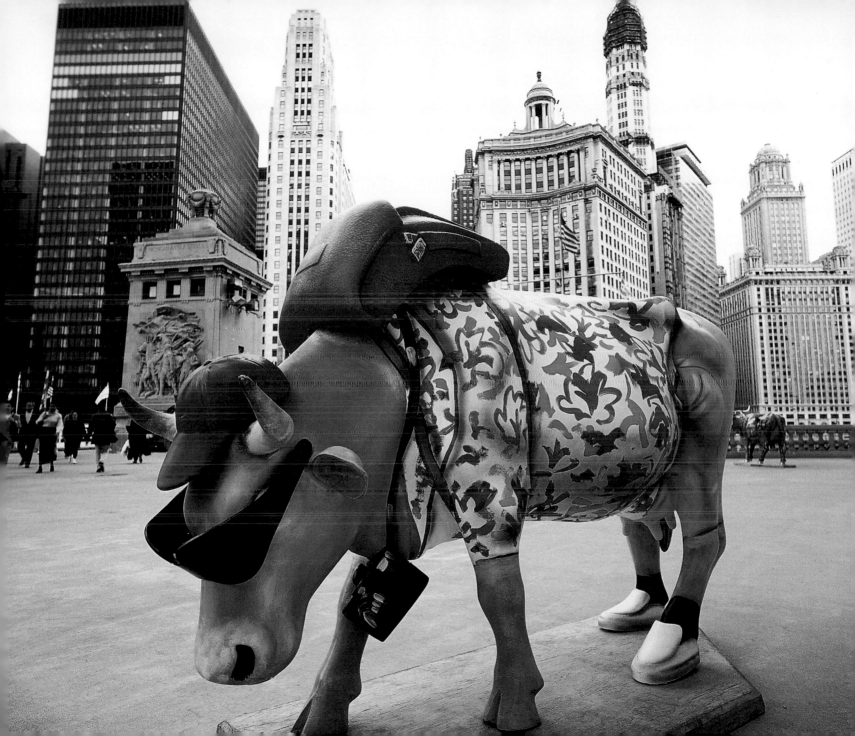

QUICKLY BECOMING PART OF THE LANDSCAPE

Ford-Red

Artist: Thomas Jocher
Patron: Austrian Cultural Institute of
New York/Austrian Consulate
General of Chicago
Location: 400–410 N. Michigan
(in the planter)

Classic Cow

Artist: James McNeill Mesple
Patron: Glenwood Ag Co.
Location: 400–410 N. Michigan

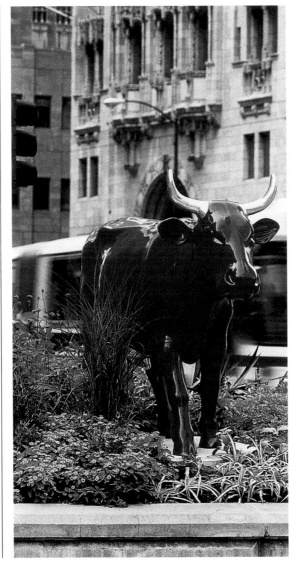

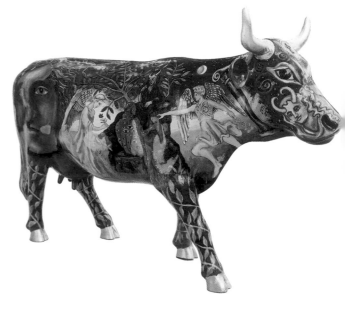

Special Events Madness

Every event celebrating the cows seemed to exceed capacity – not just by a little but by a lot. For example, the weekly Thursday night «Scavenger Hunts» – a light-hearted way to experience the exhibit – offered prizes to the first 100 people to decipher the clues and meet in front of the «Cow of the Week» at a designated time. On its inaugural night, 1,000 eager participants showed up during the first 20 minutes.

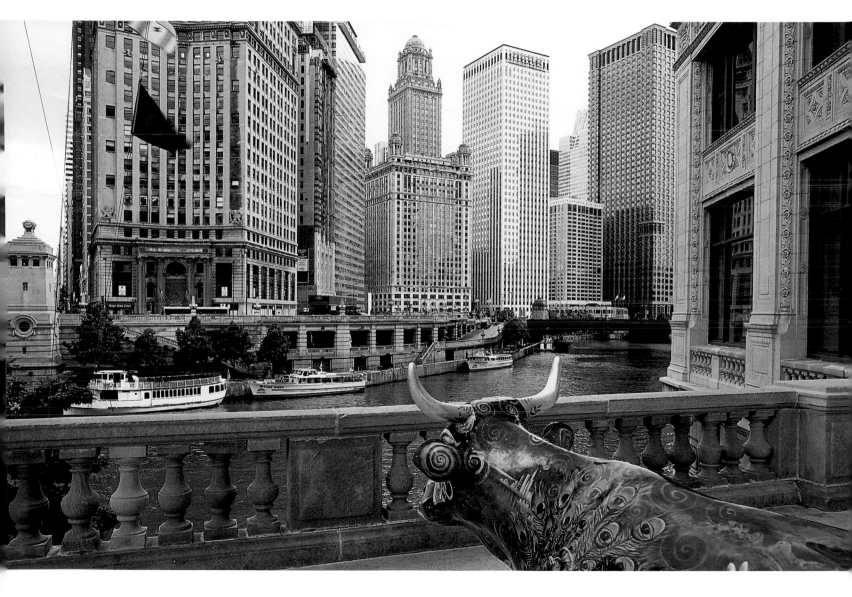

Cowbert

Artist: Lathrop Academy
Patron: Lones, Lang, LaSalle
Location: 322 N. Michigan

Untitled

Artist: Ned Broderick
Patron: National Vietnam Veterans
Art Museum
Location:
Wacker Dr. and Michigan

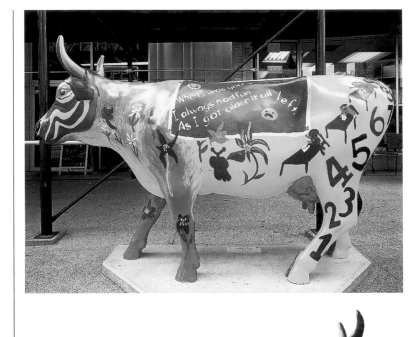

Cutting Edge Cow (in motion)

Artist:
Krueck and Sexton Architects
Patron: Wendella Sightseeing
Location: Wendella Dock, on the
Riverwalk

*Urban Re-Cowstruction and
Adaptive Reuse*

Artist: Mike Helbing
Patron:
Chicago Association of Realtors
Location: 202 N. Michigan

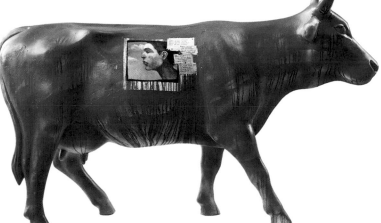

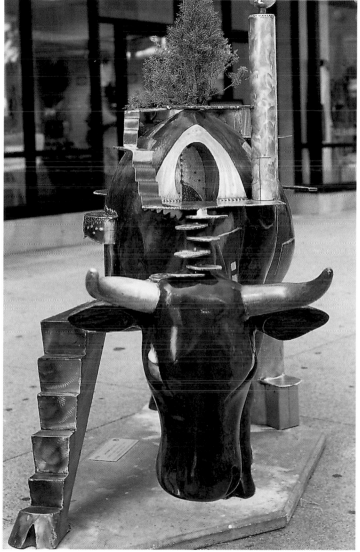

VARIATIONS ON A THEME

MICHIGAN AVENUE
(South of the Chicago River)

The Caricature Cow

Artist: Zachary Bird
Patron: Palm Restaurant
Location: Michigan and E. Wacker

The Belted Galloway

Artist: Sam Fink
Patron: Dick Anderson
Location: 333 N. Michigan

Dottie Moo

Artist: Peg Huston Miller
Patron: Lands' End
Location: 333 N. Michigan

Super Cow:
Host and Hero to World Travelers

Artist: Terrance Ward
Patron: Swissôtel Chicago
Location: Michigan and W. Wacker

Rudi, the Yodeling Cow

Artist: Tracy Ostmann
Patron: Swissôtel Chicago
Location: 303 E. Wacker

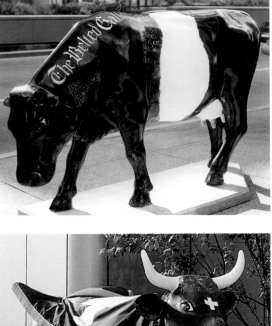

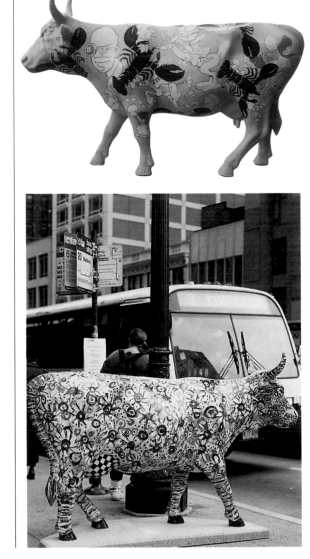

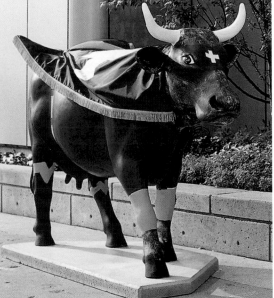

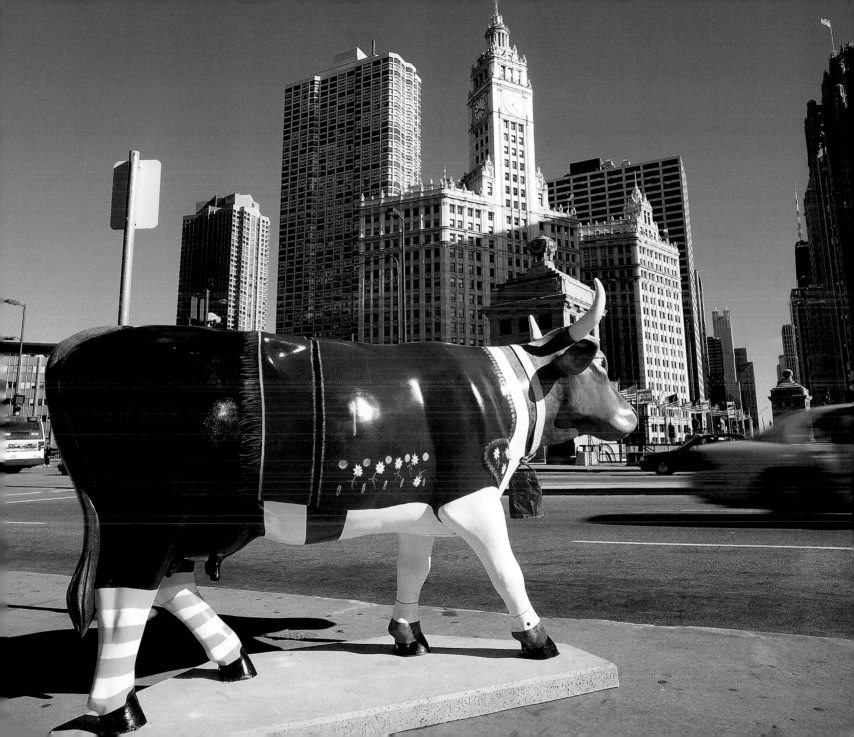

CELEBRATING ALL THE ARTS

The Cow Jumped Over the Moon

Artist: Jill Shimabukuro
Patron: Michigan Avenue Brent
Books & Cards, Ltd.
Location: 316 N. Michigan

Theater

Artist:
Chicago Academy for the Arts
Patron: Owners of 205 and 225 N.
Michigan Avenue
Location: 205 and 225 N.
Michigan at Lake

Art

Artist:
Chicago Academy for the Arts
Patron: Owners of 205 and 225 N.
Michigan Avenue
Location: 205 and 225 N. Michigan
at Lake

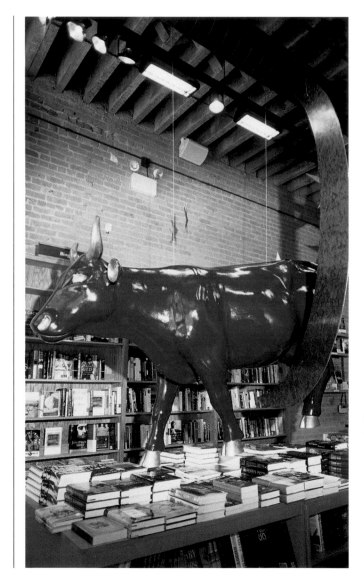

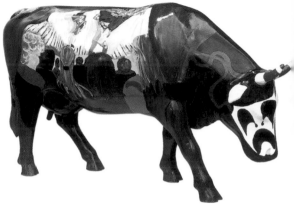

Music

Artist:
Chicago Academy for the Arts
Patron: Owners of 205 and 225 N.
Michigan Avenue
Location: 205 and 225 N.
Michigan at Lake

Dance

Artist:
Chicago Academy for the Arts
Patron: Owners of 205 and 225 N.
Michigan Avenue
Location: 205 and 225 N.
Michigan at Lake

Every public art exhibit expects some attrition – a little graffiti here, a little damage there. It's simply par for the course when art is left unprotected from the elements and unsecured from crowds. «Cows on Parade» was no exception. During one of the first nights of the installation, three teens were caught sawing a horn off one of a Michigan Avenue cows. A few nights later, several of the cows with appendages – construction cranes, eyeglasses, flags – were discovered with those parts missing. Torrential rains at the exhibit's start caused damage to some of the more fragile bovines, and several weeks into the show, the «Fern» cow got hit by a bus.

But what Michael Lash, the director of Public Art didn't anticipate, was that the cows could actually be, in his words, «loved too much.» The cows simply weren't made for the outpouring of affection they've received from the public. As a result of non-stop petting and touching, the protective finishes began to wear down. The solution? The cow hospital, of course. Lash and his cow-ordinater Nathan Mason turned the city building at State and Lake Streets – the holding pen, or «Cow House,» where many of the artists originally worked on their pieces – into a cow hospital. Cows that have sustained damage are whisked off the street by late-night crews and brought to the cow hospital where «cow paramedics» lovingly restore them to their original

splendor. Many of the cows get treated to a more durable finish – the better to protect them from the loving hands they encounter in public. So, can a cow actually be loved too much? Apparently yes, but «it's a problem I can live with,» says Lash.

Lucky

Artist: Tom Kwolik,
Christopher Tuscan
Patron: Illinois Lottery
Location: Michigan at Erie,
SE corner

Alphabet Cow

Artist: Sam Fink
Patron: Lands' End
Location: 77 E. Randolph
Street at Michigan

The Lion Cow I

Artist: John Hennessey
Patron: Grubb & Ellis Company
Location: 205 and 225 N.
Michigan at Lake

The Lion Cow II

Artist: John Hennessey
Patron: Grubb & Ellis Company
Location: 205 and 225 N.
Michigan at Lake

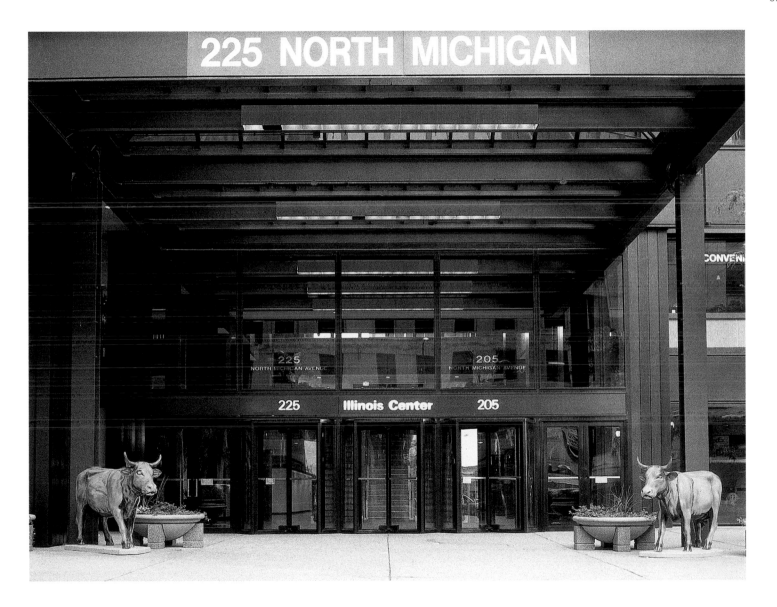

ONLY IN CHI-COW-GO

CHICAGO CULTURAL CENTER

Elevated Train

Artist: Gallery 37 Apprentice Artists
Patron: Chicago Transit Authority
Location: 77 E. Randolph Street at Michigan

Literary Lucy: The Library Lactator

Artist: John Santoro
Patron: Frankfort (Illinois) Public Library District
Randolph – Washington
Location: 77 E. Randolph at Garland

Chi-cow-go

Artist: Nancy Parkinson Albrecht
Patron: Central Michigan Avenue Association
Location: Michigan Avenue, south of Randolph

CityArts

Artist: Mary E. Young
Patron: DCA
Location: Michigan Avenue, north of Washington

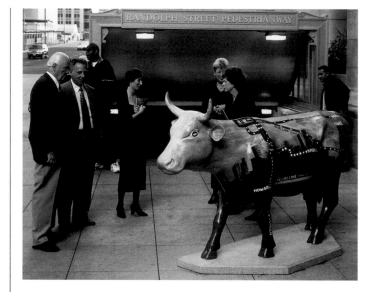

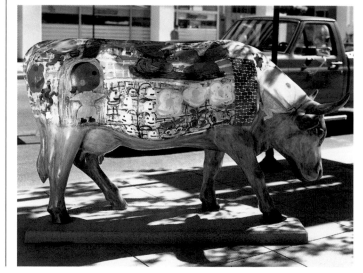

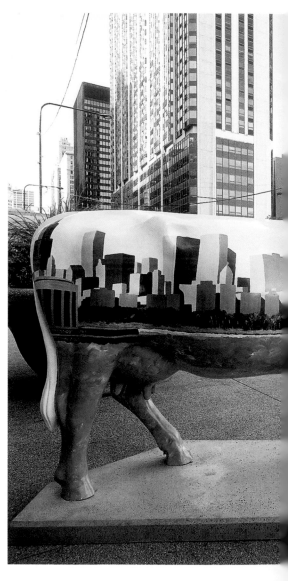

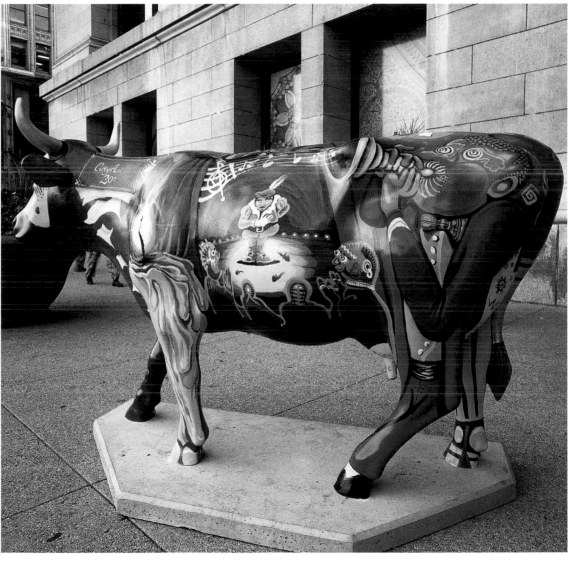

SWEET HOME CHICAGO

Sweet Home Chicago

Artist: Barbara Koenen
Patron: Where Chicago Publications
Location: 77 E. Randolph

World-Wide Media Coverage

Rarely does an art exhibit garner more than a review in the local papers. Not «Cows on Parade». Besides ongoing coverage in all of Chicago's major media outlets, it attracted the attention of the television networks, the national news magazines and CNN International, which feeds into more than 500 markets across the globe. The exhibit was featured in the news from Japan to Poland, made the cover of the Spanish language weekly, and prompted calls from dozens of cities inquiring about doing their own «Cows on Parade» exhibit next year.

Untitled

Artist: Parker
Location: 165 N. State

Untitled

Artist: Ed Paschke
Patron: Averill and Bernard Leviton
Location: 215 W. Superior

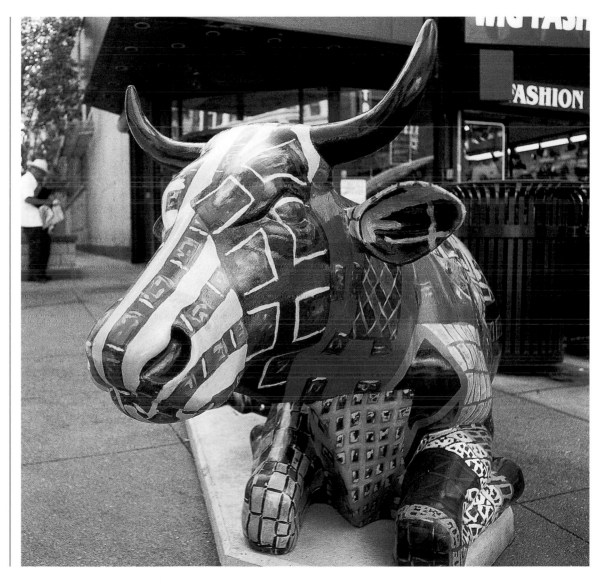

BEAUTY AND THE BEAST

Cowardly Lions (2 Cows)

Artists: Dan Bogosh and Ellen Curtis
Patron: DDB Chicago
Location:
78 E. Washington Entrance

«Moo» Net

Artist: Bonnie Zak
Patron: Stevenson & Company
Location: 20 N. Michigan

The Industrial Cow

Artist: Ken Kouba
Patron:
Consolidated Chemical Works, Ltd.
Location: Michigan and Monroe,
NW corner

Bovina Terrazzo

Artists: Karen Glaser and Michael
Cavallini
Patrons: Meg Givhan and
Jon Sollberger
Location:
78 E. Washington Entrance

*Eggplant Horn with Significant
Udder*

Artist: Tom Czarnopys
Patron: U.S. Equities
Location: 20 N. Michigan

HORSES COWED BY ART

While reactions by Chicagoans and visitors alike to Cows on Parade have been almost unanimously positive, one segment of the population has reacted a little differently: The horses from Chicago's horse-and-carriage companies. From the moment these horses set eyes on the colorful bovines, they were terrified. Not only did they balk, whinny and snort each time they spotted a cow, but they'd swerve to avoid it – putting their passengers in potential peril.

The horses' skittishness is surprising in light of what they've gotten used to while transporting sightseers around town – from car horns and careening cabbies to roaring motorcycles and fireworks explosions. But the owner of one stable thinks the size of the cows, their bright colors and sometimes outrageous patterns, as well as the way some are positioned – looking as if they might charge the street – are enough to spook the horses. And if that isn't strange enough, consider the cow that seemed to scare the horses most: «Limoosine» – a cow painted to look like a car!

Out of concern for public safety, the city hit upon an innovative solution to the horses' dilemma: Cow therapy. The Department of Cultural Affairs lent an unpainted cow to the carriage company so the horses could get acclimated to the interlopers on their turf. Each day, the fearful horses would spend time in the ring with their cow, who initially was painted a realistic black and white pattern, then bright orange, and finally a colorful, psychedelic design. In the beginning, they would merely stalk the painted lady from a distance. After some time passed, however, the horses would move in closer, sniff the cow, then encircle it as a group. For the most part, the desensitization sessions worked, and the horses grew more comfortable with their bovine companion – although often each round of therapy ended with one of the horses knocking it over, as if to indicate that they would no longer be cowed. Only two horses remained afraid, and they were taken off the street for the duration of the exhibit. The rest of the group now clop fearlessly through the streets of Chicago – successful graduates of another Chicago first: The world's first known cow therapy.

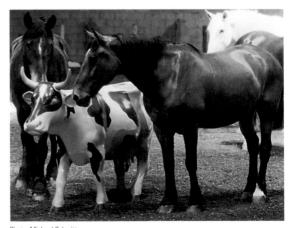

Photo: Michael Schmitt

Limoosine

Artist: Dennis Callahan
Patron: Delaware Cars and Limos
Location: Delaware and Michgan,
NW corner

The cow at right, «Limoosine», has a notoriety all its own. Painted to look like a car, it seems to be the cow that most frightens the horses from Chicago's horse-and-carriage companies.

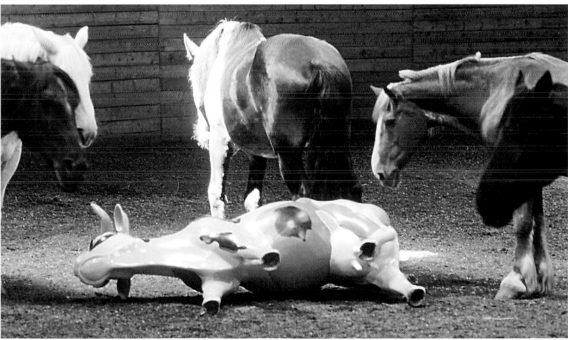

Photo: Michael Schmitt

CONCEPTUAL COWS

**THE ART INSTITUTE
OF CHICAGO**

Now

Artist: Jonathan Stein
Patron: Columbia College
Location: Columbia College,
600 S. Michigan

Through the Sullivan Arch

Artist: Mary Kelton Seyfarth
Patron: Roosevelt University
Roosevelt University,
430 S. Michigan

Collage Collaboration

Artist: CAC Members
Patron: Chicago Artists' Coalition
Location: Michigan and Adams, NW
corner

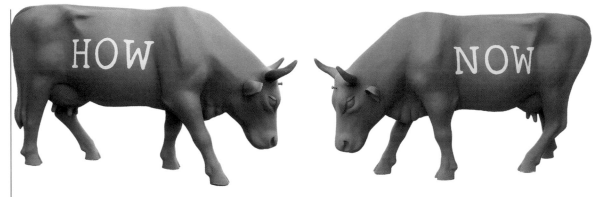

A Far-Reaching Effect

Beyond economics, beyond fun, beyond the good press, «Cows on Parade» fulfilled its true mission: making art accessible to all people, not just those who regularly visit museums and galleries. It introduced art to children, brightened the days of busy working people, delighted unsuspecting tourists, cut across educational, racial and cultural boundaries and, because it is touchable and interactive, even allowed visually impaired people to enjoy art. «Our goal was to present art in a non-threatening manner,» says Michael Lash, director of Chicago's Public Art Program. «Cows on Parade is the only time people can have an art experience without a fee or guards, as well as have one-on-one interaction with the art itself. In a sense it is Art 101 — a starting point for people to see and appreciate art.» Mission accomplished.

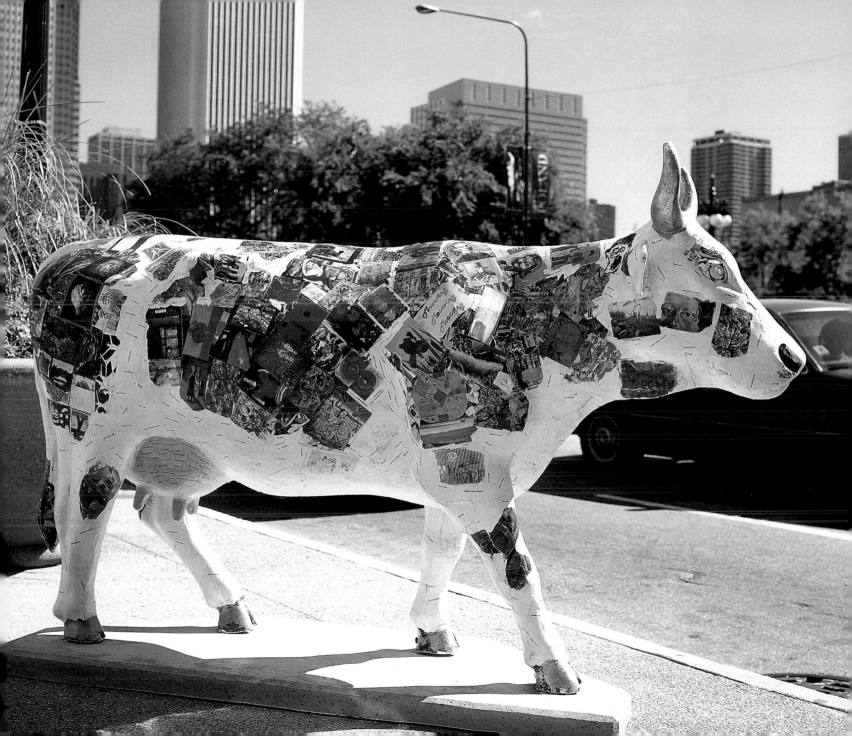

98

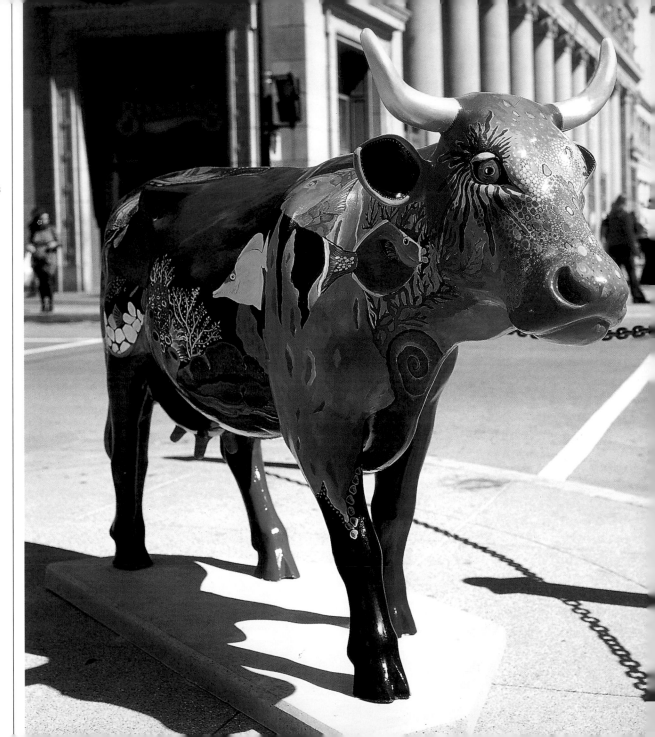

Salt Water Cow

Artist: Patty Backer
Patron: HH Backer Associates
Location: 200 S. Michigan at Adams

COW AS CANVAS

SOUTH GRANT PARK

Space Cow

Artist: Yollocalli Youth Museum
Apprentice Artists
Patron: Evans Foods
Location: Michigan and Van Buren

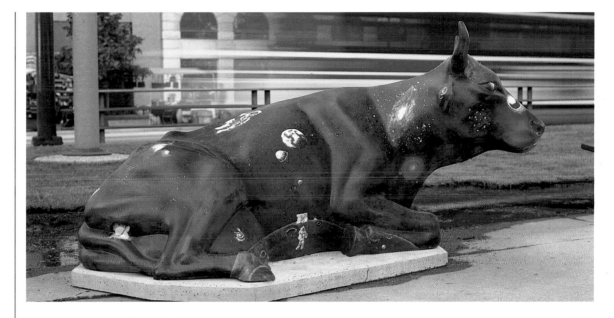

Modern Family Cow

Artist: James Kuhn
Patrons: David Fink and Kim Clark
Location: Congress Gateway

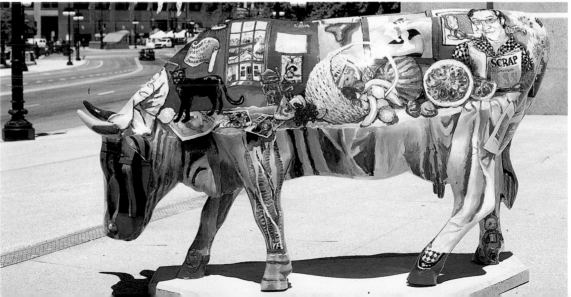

Poster Cow

Artist: Katherine Van Beuningen
Patron: Posters Plus
Location: 200 S. Michigan

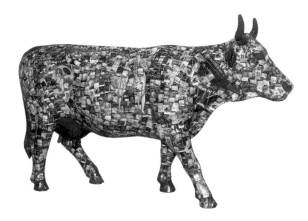

Uncle Sam

Designer: Stan Sczepanski / Flair
Communications
Artist: Kaleidoscope
Patron: Dairy Farmers of America
Location: Congress Gateway

Young at Heart

Artist: Layne Jackson
Patron: Abbott Laboratories
Location: Congress Gateway

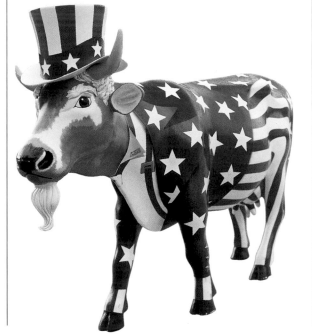

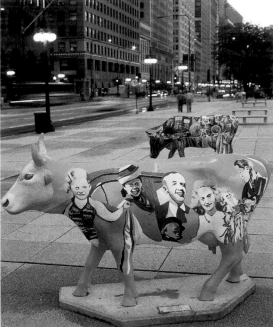

Fern

Artist: Fern Shaffer
Patron: Advocate Health Care
Location: Michigan and Adams

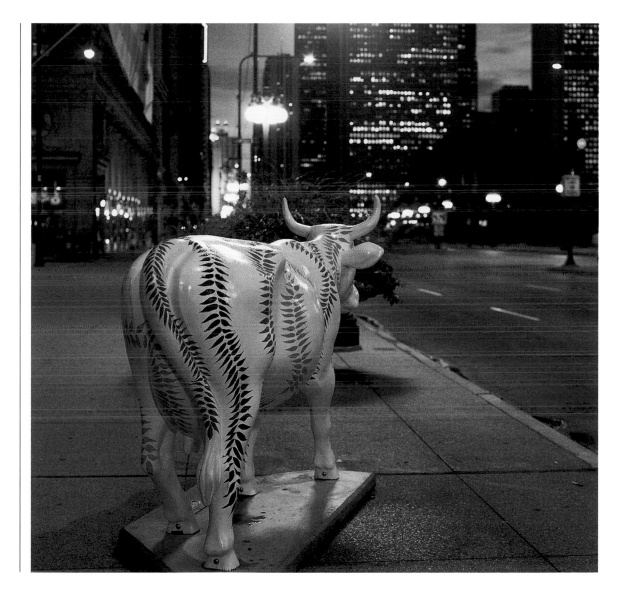

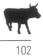

Wilhelmina Delftina de Koe I, a.k.a. Blue Moo

Artist: Sallie Haugen DeReus
Patron: Fulton Dutch Days Festival, first week in May
Location: North of Balbo

Look at That She Cow Go

Artist: Kathleen O'Reilly
Patron: Reed Coleman
Location: Congress Gateway

Crossfire Cow

Artist: William Conger
Patron: Glenn and Lynn Goldman
Location: Congress Gateway

Sky Cow

Artist: Othello Anderson
Patron: American Express
Location: Congress Gateway

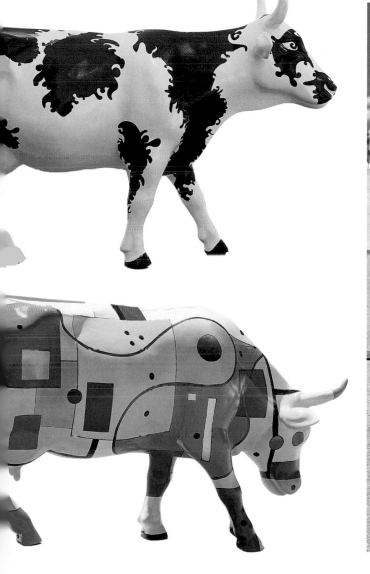

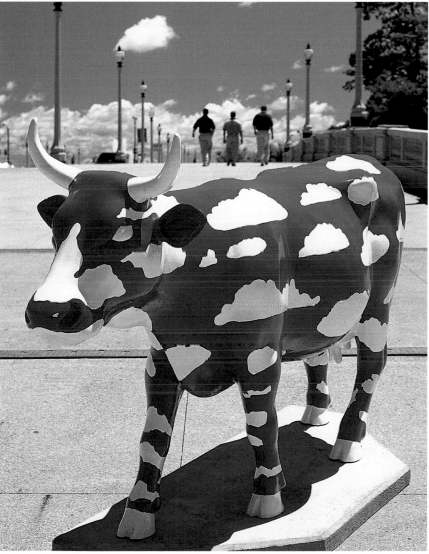

Chicago Is

Artist: Georgan Damore
Patron: metromix.com
Location: North of Balbo

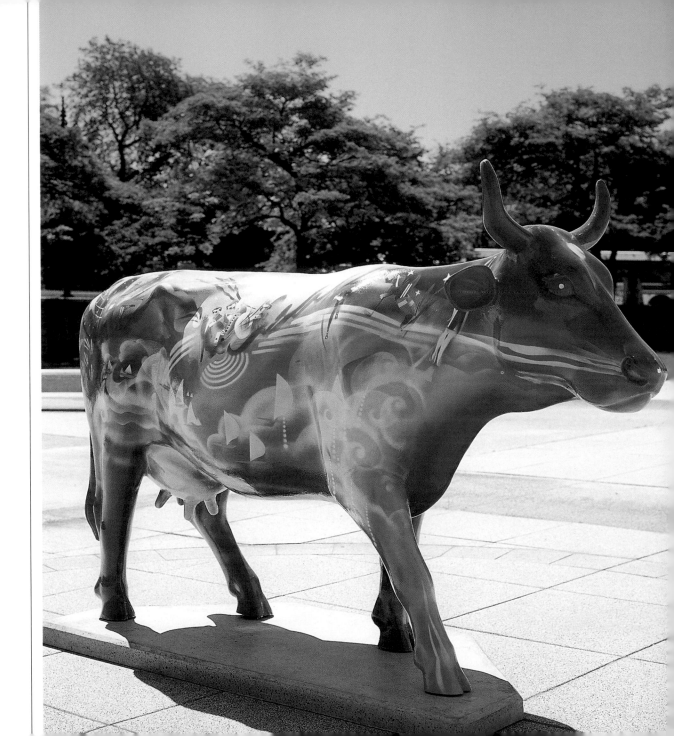

Mrs. O'Shea's Cow

Artist: Thomas White of the James
R. Doolittle Jr. Middle School
Patron: Hilton Chicago and Towers
Location: 740 S. Michigan

HANDsome by
Children's Moo-morial

Artist: Stephanie Thornton and
Patients of Children's Memorial
Hospital
Patron: James R. Donnelley
Location: Harrison – Balbo

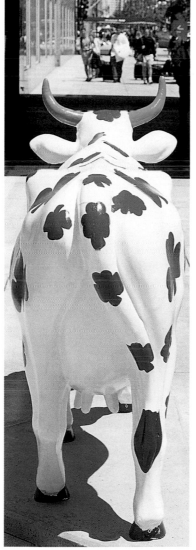

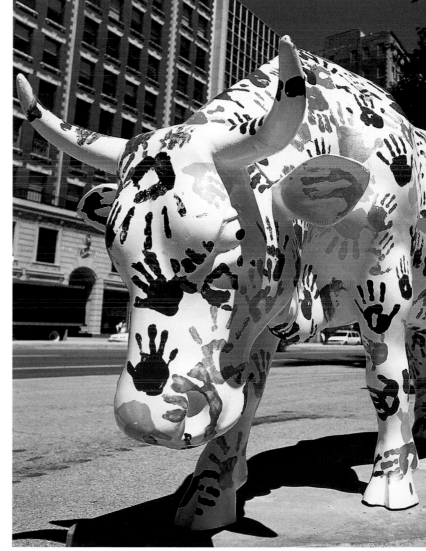

Moollennium

Artist: Malgorzata Sobus
Patron:
Chicago Millennium Celebration
Location: Harrison and Balbo

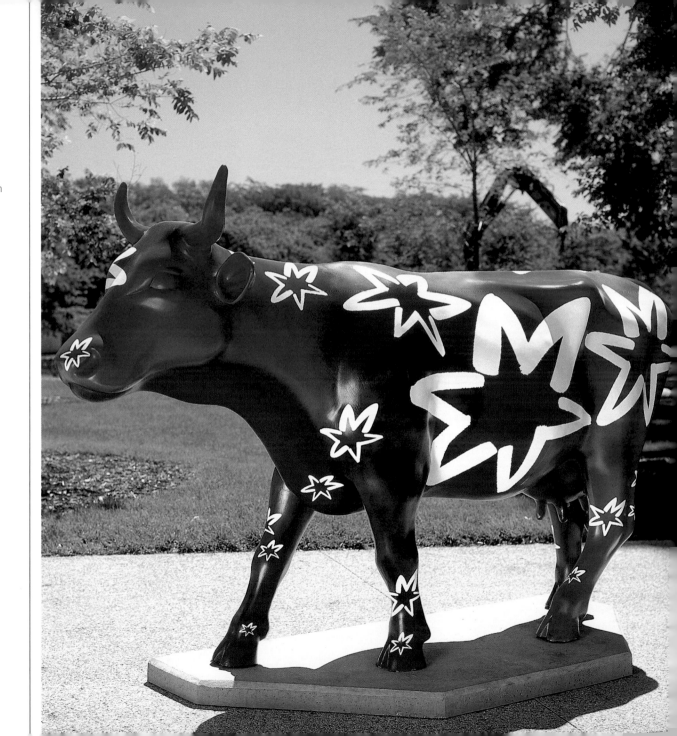

COW MOO-SEUM
STATE STREET
BRIDGE GALLERY

Pi-COW-so ①

Artist: Herbert Migdoll
Patron:
The Joffrey Ballet of Chicago
Location: State and Wacker

Bettsy the Syber cow ②

Artists: Marcos Raya with Kenneth
Morrison, Eric Tenfelde
Patron: Mary and Roy Cullen
Location: State and Wacker

Mooving Company ③

Artist: Karl Wirsum
Patron: DCA
Location: State and Wacker

Cow from Home (Africa) ④

Artist: David Philpot
Patron: Intuit: Center for Intuitive
and Outsider Art
Location: State and Wacker

Cow(ed) ⑤

Artists: Stanley Tigerman,
Dong Huy Kim
Patron: DCA
Location: State and Wacker

Gladiebelle

Artist: Gladys Nilsson
Patron: DCA
Location: State and Wacker

W. la Vaca 1999 #2

Artist: Virginio Ferrari
Patron: DCA
Location: State and Wacker

Some of the most valuable cows by some of the most famous artists in the show are on display at the State Street Bridge Gallery, otherwise known as the Cow Moo-Seum, located on the river walk at State Street and Lower Wacker Drive. This one-of-a-kind gallery — little more than rough space that houses the drawbridge's gears and inner workings — is frequently used for public art projects.

Cow Catchers

Who would have thought that these fiberglass creatures would inspire a legion of protectors? But that's exactly what happened. Stories circulated of concerned citizens chastising their less-than-concerned brethren about mistreatment of the cows; one woman even chased a man for several blocks after she saw him inexplicably kick a cow. At the WGN studio overlooking the cow-studded Pioneer Court, popular radio personalities Kathy O'Malley and Judy Markey became *de facto* mother hens for the «Holy Cow», which resides just outside their window. They've had no qualms about scolding people on air for trying to sit on «their cow.» «We have come to think of it as our cow,» Markey explains. «So we have taken it upon ourselves to prevent cow crime and make sure that our cow stays safe.»

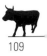

Free Form Cow Form ①

Artist: Richard Hunt
Patron: DCA
Location: State and Wacker

Untitled ②

Artist: David Klamen
Patron: DCA
Location: State and Wacker

Metamorphosis ③

Artist: Vivian Nunley
Patrons: Peggy Notebaert Nature
Museum/Chicago Academy of
Sciences
Location: State and Wacker

Cowffalo ④

Artist: Ruth Duckworth
Patron: DCA
Location: State and Wacker

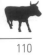

NECESSITY IS THE MOTHER OF INVENTION

She's Got Legs …
And She Knows How To Use Them

Artists: Terrence Karpowicz, Elaine
Uellendahl with assistance from
Northwestern University Prosthetics
and Orthotics Center
Patron: Anne and Warren Weisberg
Location: State and Wacker

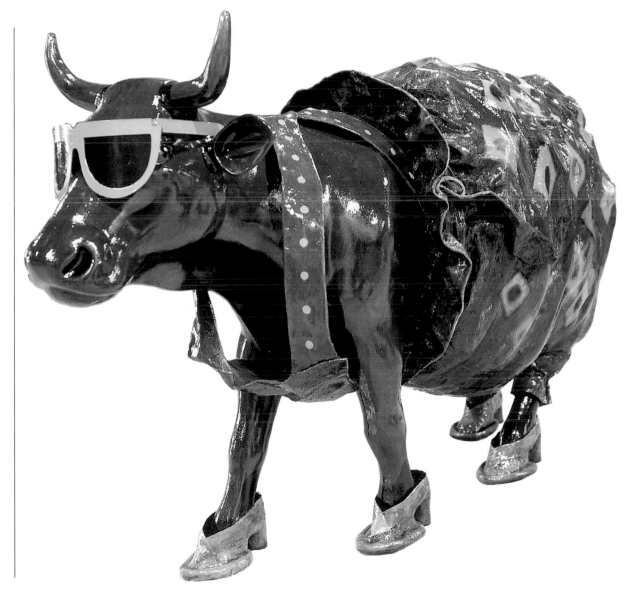

Secondary Colors

Artist: Vesna Lazar
Patron: Vesna Lazar
Location: State and Wacker

EAST WACKER DRIVE

Accidental Tourist

Artist: Tom McCaffrey
Patron: Mercury: Chicago's Skyline
Cruise Line
Location: Michigan and Wacker
On the boat Skyline Queen

Stampede, Rush Street Bridge, 1863

Artists: Jan Carmichael and
Ken Warneke
Patron: Chicago Sun-Times
Location: Wacker, west of Michigan

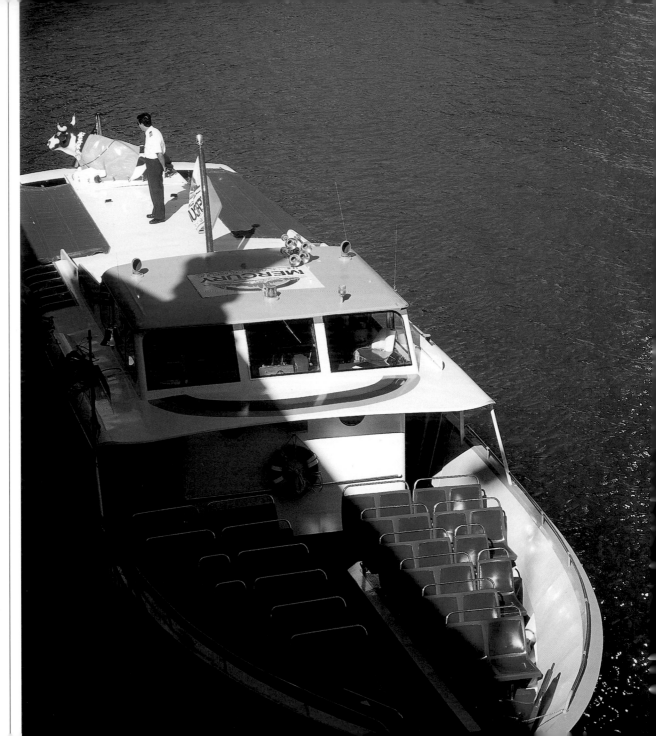

Saga of the Stampede

This area marks the site of the old Rush Street Bridge. It was a major livestock thoroughfare until 1863 when a herd of cattle caused its collapse. More than 100 bovine were lost that day and the bridge was never rebuilt. Today, if you listen closely, you may hear the sound of phantom moos.

Cows on Parade™
Chicago Sun-Times

TROMPE L'OEIL

RIVER NORTH

In Disguise

Artist: John Loftus
Patron: Smith & Wollensky
Location: Marina City, 318 N. State

Stampede, Rush Street Bridge, 1863

Artist: Jan Carmichael and
Ken Warneke
Patron: Chicago Sun-Times
Location: Rush Street at the River

Cowbeille De Fruits

Artists: Juliet Sender, Decima
Szulczewski, Eva Sandor, Lisa
McComb
Patron: River Plaza Community
Location: 405 N. Wabash

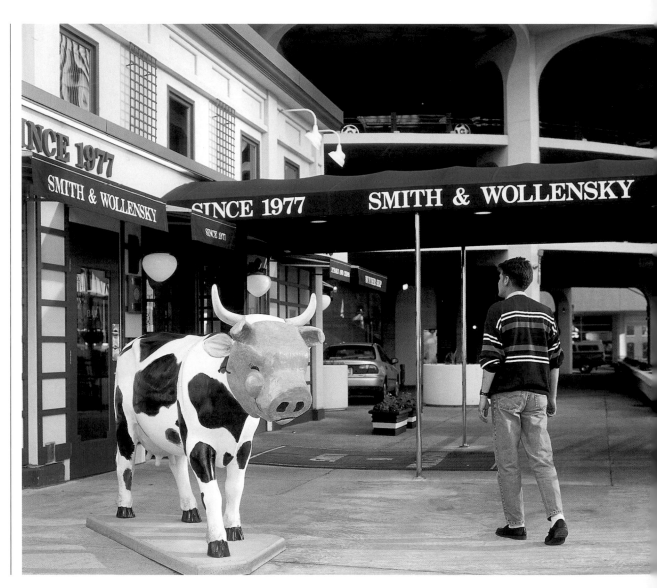

«Cows on Parade» may be Chicago's biggest art project celebrating cows, however, it is certainly not the first – a fact that comes as no surprise given the supporting role cows have played in Chicago's history. All across town, cows can be found incorporated into a variety of artistic mediums from building ornamentation to oil paintings. One of the most appropriate depictions of cattle graces the old Stockyards gates at the corner of Exchange and Peoria Streets. Designed by the architectural firm of Burnham and Root in 1879, the carved limestone gates feature a prize-winning bull called Sherman, named in honor of the man who ran the stockyards, John B. Sherman.

Other places where cows have been corralled by art include:

The Art Institute of Chicago, 111 S. Michigan Avenue: Three paintings at this leading cultural institution depict cows in various life stages, including Georgia O'Keefe's «Cow's Skull with Calico Roses», Jean-François Millet's «Peasant Bringing Home a Calf Born in the Fields», and Francis Bacon's «Head Surrounded by Sides of Beef».

The Chicago Historical Society, 1601 N. Clark Street: Hanging in the Historical Society's Big Shoulders restaurant is the terra cotta arch from the Union Stockyards' bank and office building. Carved by Burnham and Root in 1888, the arch depicts, among other things, a herd of cattle.

The Old Chicago Mercantile Exchange Building, 110 N. Franklin Street: With 1,927 cows carved into the face of the building by sculptor Emil Zettler, this site is a virtual cow bonanza.

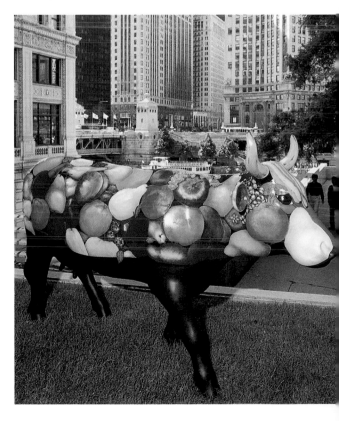

The Driving Force in Ar-COW-tecture

Artist: Don Drabik,
Amundson/Drabik
Patron: Friedman Properties
Location: 320 N. Clark

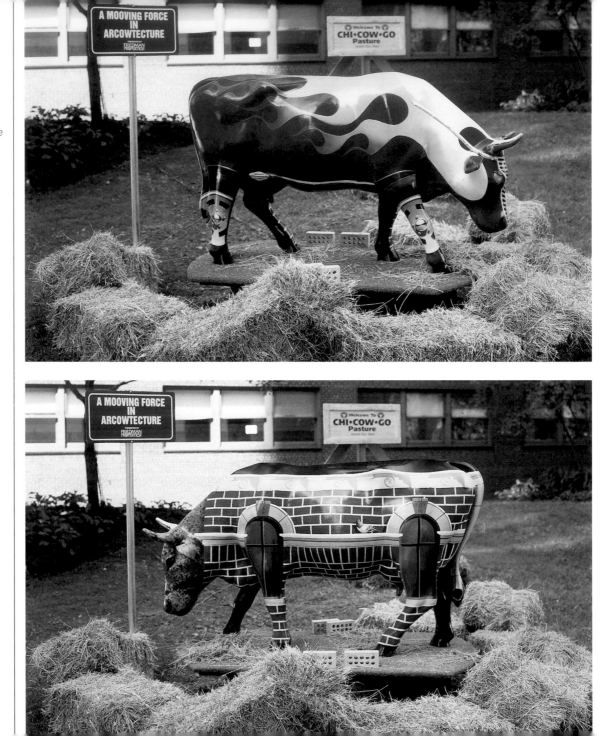

Cowch Potato

Artist: Kevin Snow, Artifex
Patron: Kurtis Productions
Location: 320 N. Clark

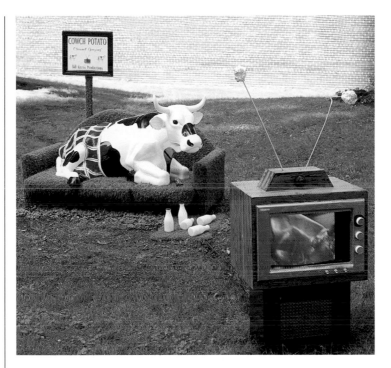

Graffiti, Abstract Cow

Artist: Linda Kramer
Patron: Doris Conant
Location: 445 N. Wells at Hubbard

Belle Pepper

Artist: Marcellus Smith
Patron: Pepper Construction
Location: 643 N. Orleans at Ontario

SILLINESS TAKES CENTER STAGE

Muddy Holly and Peggy Sue

Artist: Kristin Neveu
Patron: Ed Debevic's/Edy's
Grand Ice Cream
Location: 640 N. Wells at Ontario

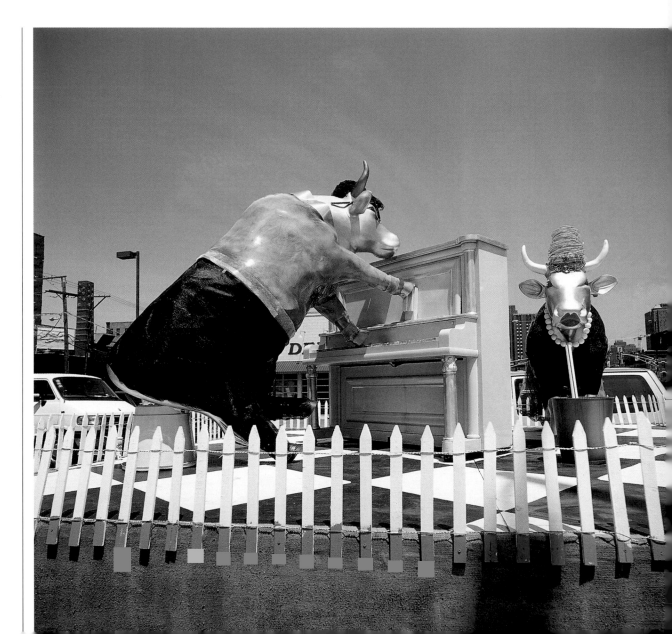

STATE STREET

Text Cow

Artist: Art and design students of
Robert Morris College
Patron: Robert Morris College
Location: State and Van Buren

A Step Back in Time

Artist: John Hennessey
Patron: Grub & Ellis Company
Location:
1 N. State at Madison

Zinnia Garden

Artist: B.R. Sweeney
Patron: J.P.S. Interests
Location: 30 W. Monroe

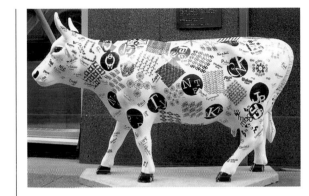

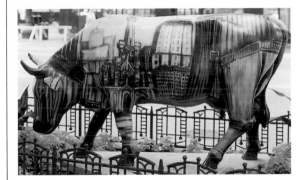

Immortalized in song as «State Street, that Great Street» by Frank Sinatra, who definitely thought Chicago was his kind of town, State Street made its name as *the* shopping street in all of the Midwest. In fact, around the turn of the century, the corner of State and Madison was reputed to be the busiest in the world. The street took a plunge in popularity during the last 30 years, however, as people moved to – and shopped in – the suburbs. For a time, State Street was even made into an urban mall of sorts, cordoned off from car traffic, which unintentionally isolated it from the rest of the Loop. Today, with a recent facelift, a reintroduction of car traffic and a resurgence of urban dwellers, State Street has been transformed into a great bustling area once more. (It also makes a great temporary cow pasture!)

COWS THAT WOW

Image Cow

Artist: Art and design students of
Robert Morris College
Patron: Robert Morris College
Location: State and Van Buren

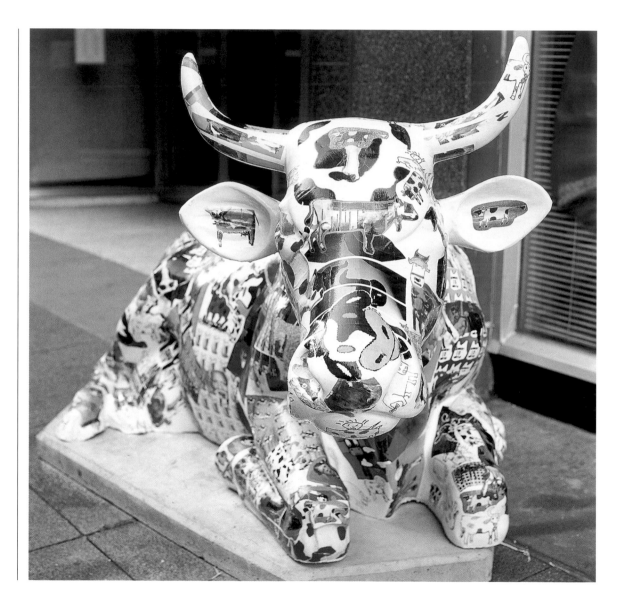

Carson: *The Celebration Cow*

Artist: Linda Mueller
Patron: Carson Pirie Scott & Co.
Location: 1 S. State

Untitled

Artist: SOM
Patron:
Skidmore, Owings and Merrill
Location: 220 S. State

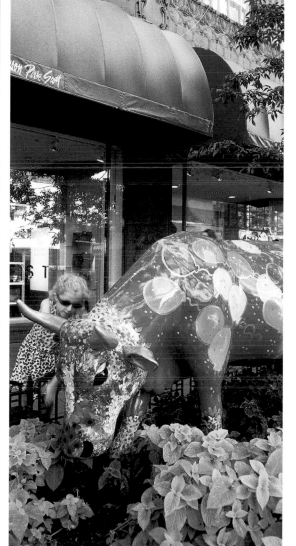

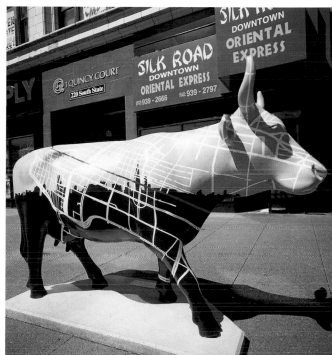

… cow

Artist: Lee Tracy
Patron: Dick Ross, Scribcor Inc.
Location: Lobby of Inland Steel
Building

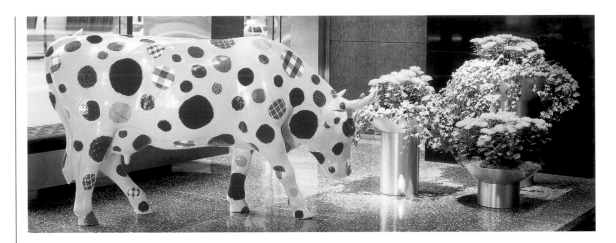

Give the Lady What She Wants

Artist: Tom Bachtell
Patron: Marshall Field's
Location: Randolph and State

Inspired by Bertha Palmer's Closet

Artist: Maryanne Warton
Patron: Palmer House Hilton
Location: Palmer House Hilton,
17 E. Monroe

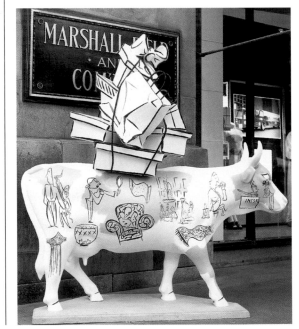

Palmer House Aristocow

Artist: Maryanne Warton
Patron: Palmer House Hilton
Location: Palmer House Hilton,
17 E. Monroe

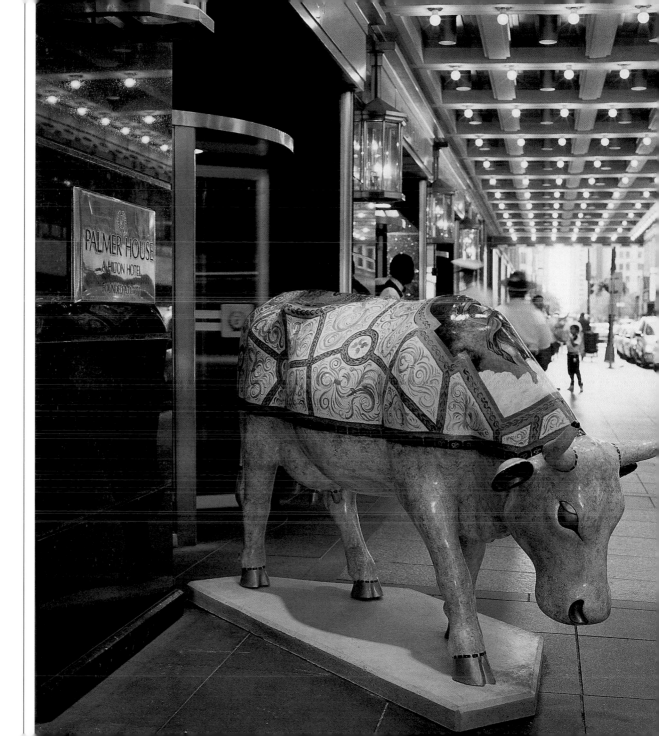

Psychedelic

Artist: Rob Davis
Patron: Renaissance Chicago Hotel
Location: Renaissance Hotel, 1 W. Wacker

Mosaic

Artist: Andrew Rubinstein
Patron: Renaissance Chicago Hotel
Location: Renaissance Hotel, 1 W. Wacker

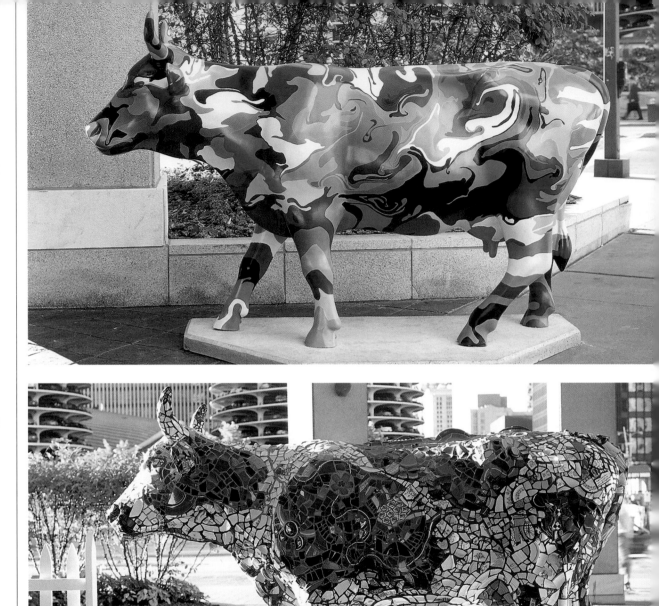

Lines

Artist: Helmut Jahn
Patron: Sara Lee Corporation
Location: 1 W. Wacker at State

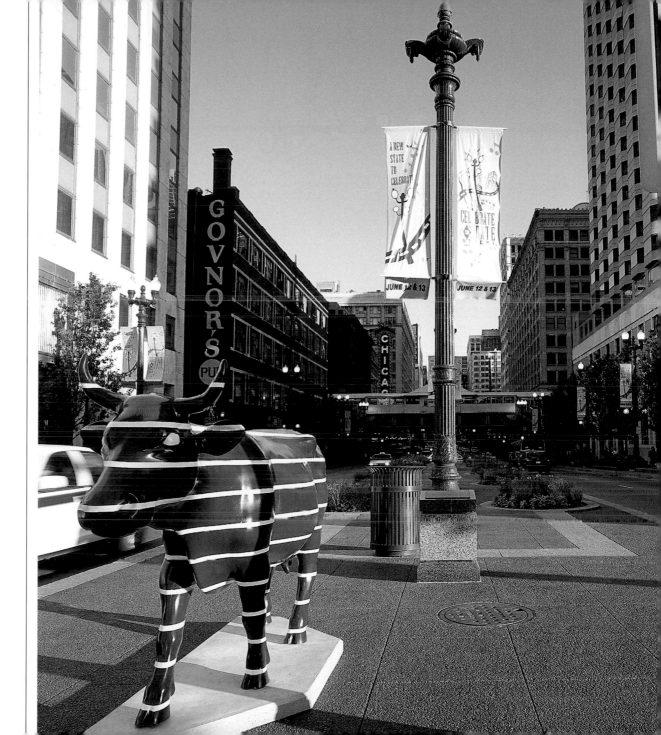

DALEY CIVIC
CENTER PLAZA

Bucolic @ Xtreme

Artist: Irene Siegel
Patrons:
Lewis S. and Anne Neri Kostiner
Location: Daley Civic Center Plaza

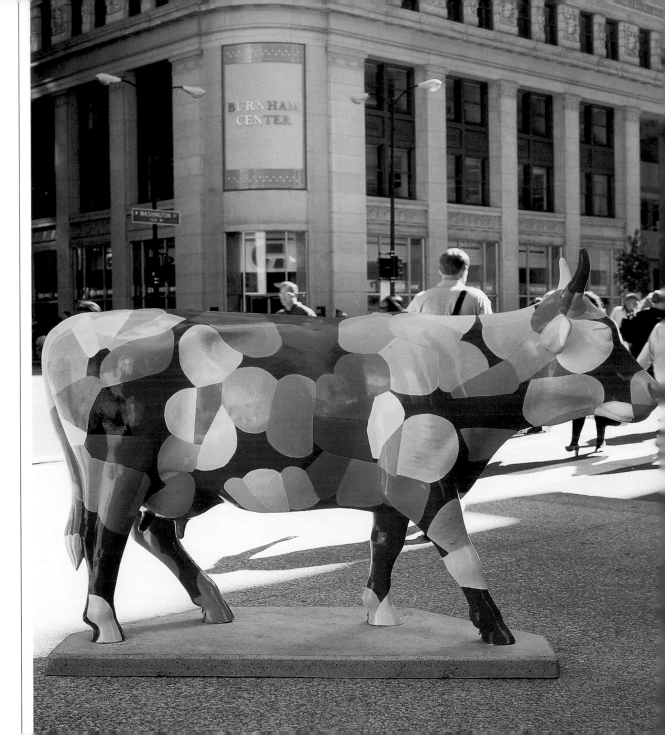

Bridge Cow 1 and 2

Artist: Chris Holt
Patron: Chicago Department of
Transportation
Location: State Street Bridge

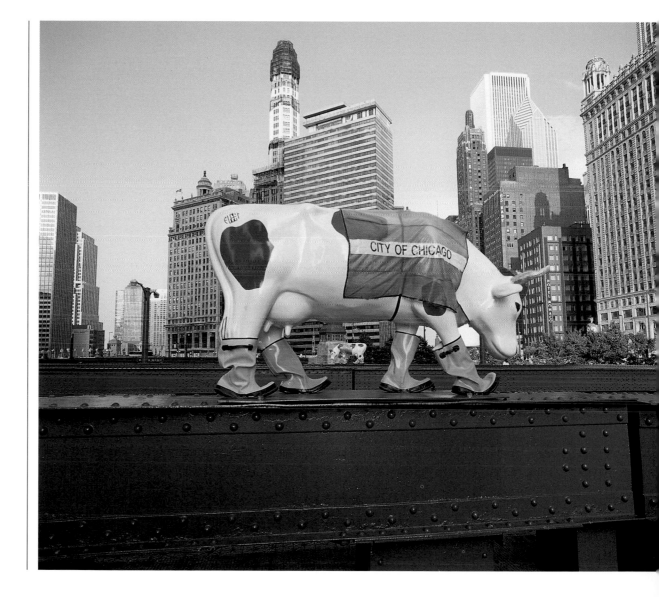

Untitled

Artist: Don Capuli
Patron: Bud and Mimi Frankel
Location: Wacker and Wabash
(NE corner)

Pit Bull Cow

Artist: Lohan Associates/James
Goodspeed
Patron: The Lurrie Company
Location: LaSalle and Wacker

Untitled

Artist: Unknown
Patron: Harold Washington College
Location: 200 N. Wabash

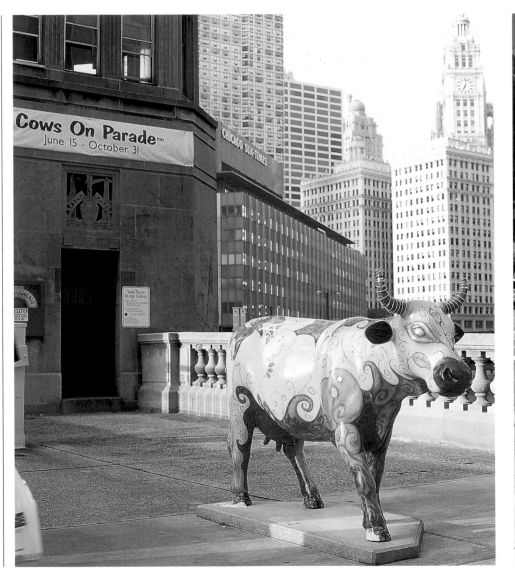

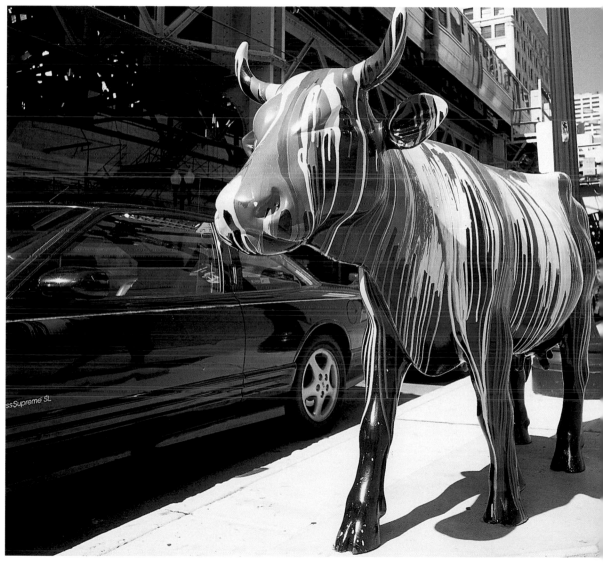

FROM ZURICH TO CHICAGO

Zürich – Little Big City 1

Artist: Jürg Bächtold
Patron: Zürich Tourism
Location: Daley Civic Center Plaza

Zürich – Little Big City 2

Artist: Jürg Bächtold
Patron: Zürich Tourism
Location: Daley Civic Center Plaza

Zürich – Little Big City 3

Artist: Jürg Bächtold
Patron: Zürich Tourism
Location: Daley Civic Center Plaza

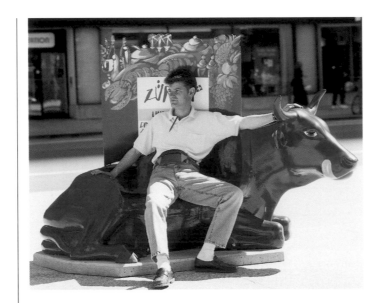

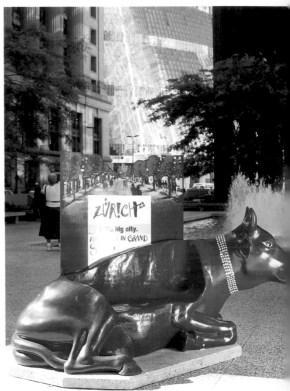

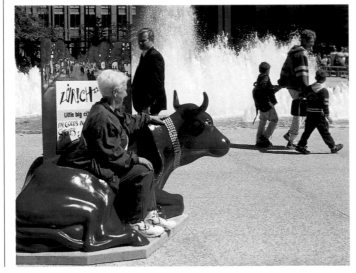

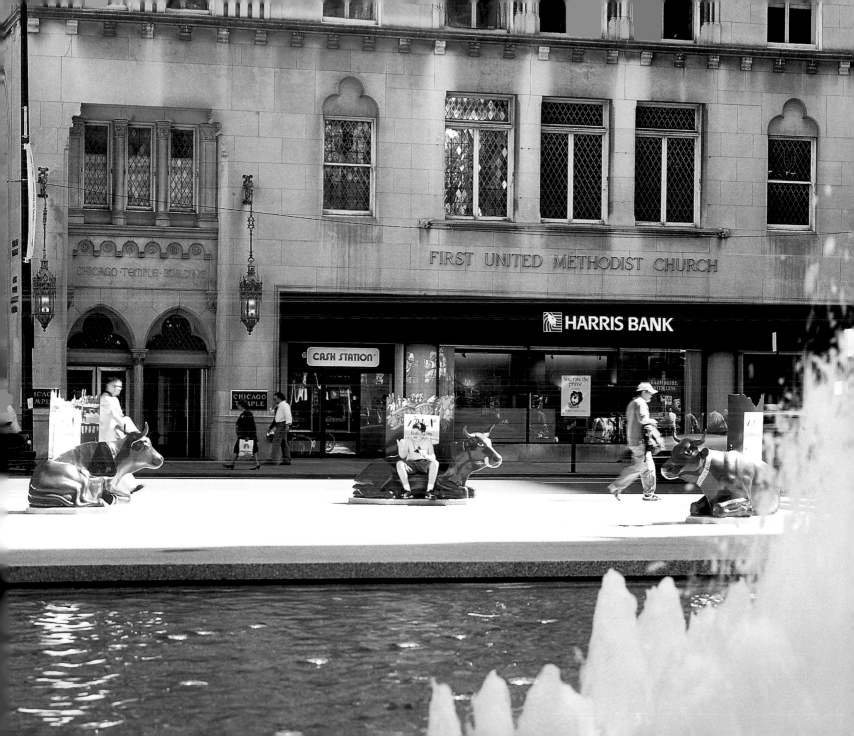

A TALE OF TWO CITIES

September 9–19th, 1999

Artist: Cordula Huber
Patron: Swiss Week in Chicago
Location: Daley Civic Center Plaza

Bridging Two Wonderful Cultures

Artist: Cordula Huber
Patron: Consulate General of
Switzerland
Location: Daley Civic Center Plaza

Guernsica

Artist: Karl Kochvar
Patron: The Goodman Theater
Location: Columbus and Monroe

Silencing the Birds

Artist: Teresa Hofheimer
Patron: The Art Institute of Chicago,
The Art Institute Garden
Location: 111 S. Michigan

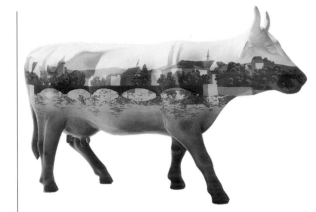

The cow above was developed to promote Swiss Week in Chicago, scheduled for September 9 to 19, 1999. If «Cows on Parade's» success is any indication of the rapport already forged between the Windy City and the alpine nation, the weeklong celebration of Swiss culture in Chicago should be udderly irresista-bull.

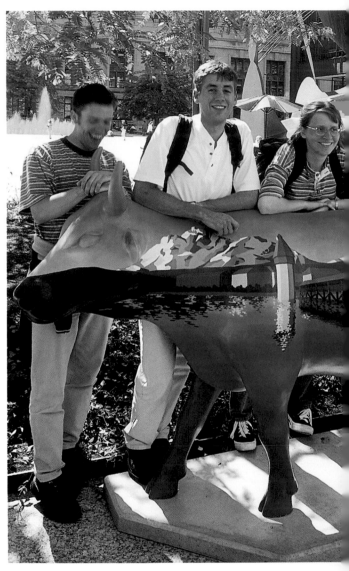

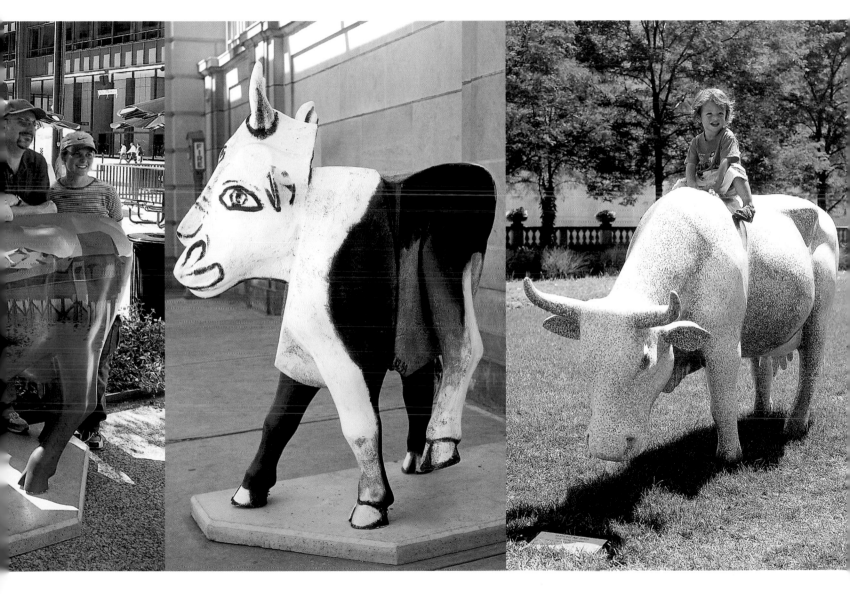

Moo-n Light

Artist: Philip Kotulski
Patron: COMED
Location:
Dearborn north of Monroe

How Are You?

Artist: Samuel Akainyah
Patron: Philip J, Wicklander
Location:
Union League Club, 65 W. Jackson

The Cow that jumped over the moon

Artist:
The Children of Isaac Fox School
Patron: Swiss Businesses
From the Suburbs
Location: 50 W. Washington

Summer Heat

Artist: Barbara Domalewski
Patron: Bank of America
Location:
Bank of America, 231 S. LaSalle

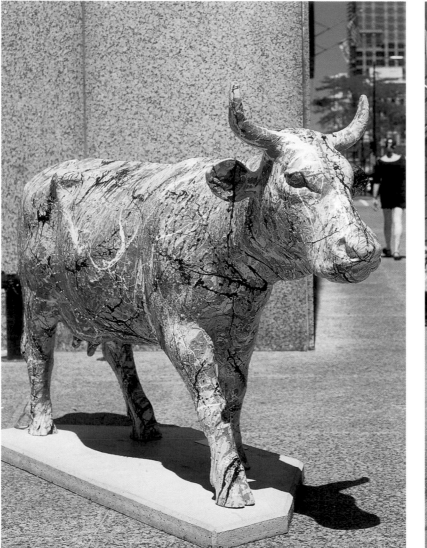

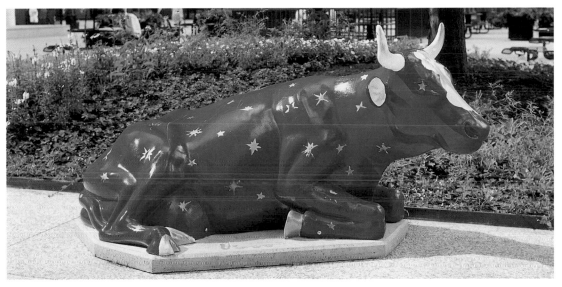

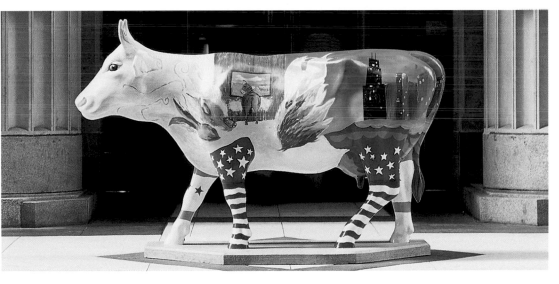

Trying to describe Chicago is a bit like trying to describe someone you love: Impossible because that person is more than the sum of his or her parts, and frustrating because the qualities that are most appealing are also the most intangible. Like interesting people, Chicago is full of paradoxes. It's large, but livable, imposing but accessible, sophisticated but no-nonsense. It's a city of the landlocked Midwest that has a wave-splashed coastline and downtown beaches. It's a city on the edge of prairie and farmlands that made its fortunes in manufacturing and industry. It's a city with a tough reputation but a soft spot for the arts. It's a city that overwhelms you with its sheer size and vast energy, but surprises you with the easygoing friendliness of its locals. Yet like all interesting people, Chicago also has its flaws – including a past littered with big-time wheeling-and-dealing and small-time hoodlums – which today are actually part of its charm. Those days may be long gone, but even as the city changed, it never let go of its brash roots. Chicago's thirst for the new, its boldness and willingness to take a risk, and its «bigger is better» philosophy have remained the same.

Today, Chicago leads the country in everything from candy manufacturing to automobile sales. It's home to the world's busiest airport, the nation's largest convention center, the country's biggest building outside the Pentagon, and three of the world's tallest skyscrapers. The city is the international leader in the trading of commodities, stock options, currency and interest rate futures, and boasts the world's largest and oldest futures and options exchange. Chicago has more restaurants than Manhattan, busier expressways than LA, and retail stores that gross more than anywhere else in the United States.

From its earliest years, Chicago has lavished equal attention to both business and the arts. It has the third largest office market in the U.S. and Europe, but also the world's largest Impressionist and Post-Impressionist art collection outside of Paris. The city is headquarters to 35 Fortune 500 companies and also to more than 200 theater companies. Chicago is the number-one destination of U.S. business travelers, but for those who want to expand their horizons in other ways, there's The Harold Washington Public Library – with approximately 2 million books, it is the world's largest municipal building. The city is also home to two of the top-rated business schools in the nation, including the University of Chicago, which happens to have more than twice the Nobel Laureates than any other institution in the world.

Clearly, Chicago is a serious city. But part of its appeal is that it never takes itself too serious. It's a city that dyes its river green on St. Patrick's Day, a city that marks major holidays with colored lights on

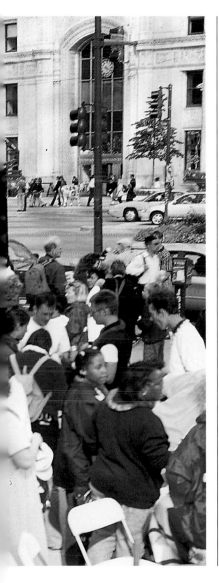

its most prominent buildings, a city that can come to a standstill during a championship sporting event. It's a city that celebrates summer with countless parades and neighborhood festivals, weekly fireworks off of Navy Pier, and an outdoor food festival that draws more than 3 million visitors. For the city that introduced the world to roller skates and Cracker Jack, Twinkies and McDonald's hamburgers to take itself too seriously would be unthinkable; Chicagoans consider themselves far too down-to-earth to put on airs. And anyone who does, simply gets booed out of town.

Visitors, however, are always welcome, and each year, more than 25 million come to Chicago. They come to walk the Magnificent Mile – the stretch of Michigan Avenue from Oak Street to the north and the Chicago River to the south that's lined with fashionable stores, vertical malls and luxury specialty shops. They come to take in exhibits at the 46 museums scattered throughout the city and check out the latest on the art scene at the nearly 200 galleries concentrated in the River North district. They come to broker deals in the Loop's office towers, sample the delights of the city's more than 7,000 restaurants, walk, bike or blade with the locals along the 29 miles of lakefront paths, catch a Bulls game at the new United Center, or spend an afternoon watching baseball at Wrigley Field. Music lovers from around the globe flock to the annual free jazz, blues and gospel festivals in Grant Park, as well as make pilgrimages to the tiny neighborhood clubs where Chicago musicians defined the blues tradition and influenced contemporary rock and roll. And theater aficionados make sure to see the latest productions at the award-winning Steppenwolf, Court and Goodman theaters.

Those who venture away from downtown will find one-of-a-kind neighborhoods that offer a different interpretation of the city: Ultra-hip restaurants and funky establishments in the Wicker Park neighborhood to the west; upscale stores and eateries in the Lincoln Park/DePaul area to the north; a reinvigorated Bronzeville on the African-American dominated South Side; a touch of old Germany in the Northwest Side's Lincoln Square; and examples of architect Frank Lloyd Wright's work preserved in both Hyde Park and suburban Oak Park. There are thriving Hispanic communities in Pilsen, Little Village and Humbolt Park, a vibrant Indian community along Devon Avenue, the largest Polish population outside of Warsaw in the neighborhoods bordering Milwaukee Avenue, and active Asian communities from Chinatown to Argyle Street. Over the years, these neighborhoods have been shaped not only by what these immigrant groups brought from their homeland but by the spirit of the city itself – a spirit that embraces the future while honoring the past.

Today, that spirit is alive throughout Chicago as the city continues to transform itself once again. With a healthy economy, an optimistic outlook, and a mayor committed to a city that looks as good as it works, Chicago is being rebuilt, remodeled, revamped, rehabbed and rerouted. Several years ago, a former working dock, Navy Pier, was remade into a festival marketplace complete with grand ballroom, restaurants, a Ferris Wheel and a Shakespeare theater company; it now attracts more than 7 million visitors annually. The lakefront airport, Meigs Field, will soon become a park. The neighborhood that runs west along Madison to the United Center has gone from Skid Row to pricey loft condos. The Reliance Building, the crown jewel of the Chicago School of Architecture that had fallen into disrepair, is being restored to its former glory. The opulently refurbished Oriental Theater has recently reopened, and the once grand, now seedy Harris and Selwyn Theaters are being restored as the new home of the Goodman Theater. Parts of the famed Lake Shore Drive were rerouted to allow for the new Museum Campus – a flower-lined greensward that links the Field Museum, the Shedd Aquarium, the Adler Planetarium and Soldier Field. What's most interesting about these changes is that Chicago is finding ways to accommodate both its past and future to create a vital present – a city that's much like the Chicago Carl Sandburg described decades earlier: «Come and show me another city,» he wrote, «with lifted head singing so proud to be alive and coarse and strong and cunning.» That city, full of paradox and pride, is none other than Chicago.

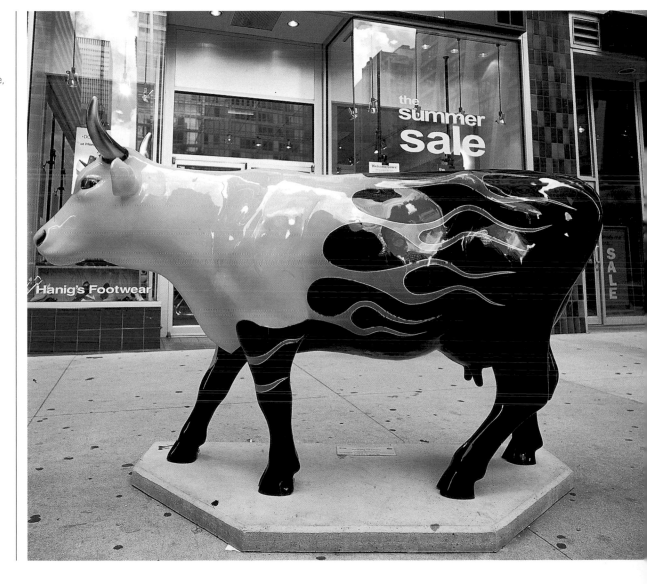

Be-bop a Re-bop

Artist: Nancy Hild assisted by
C&W Autobody
Patron: Hanig's Footwear
Location: Clark and Monroe Avenue,
NW corner

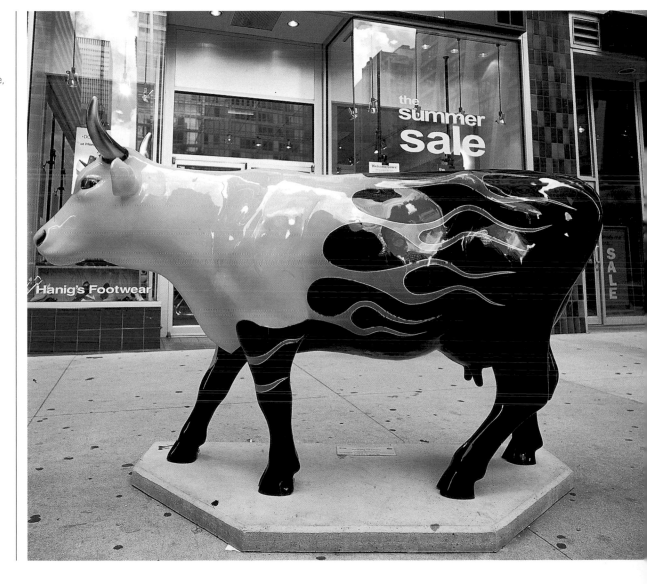

FINANCIAL DISTRICT
Board of Trade, East Side

Cow Scape

Artist: Emmett Kerrigan
Patron: O'Connor and Co.
Location: Board of Trade Courtyard

Come Dip On In:
A Love Story from the Big Bar

Artist: Sandi Chaplin
Patron: Friends of Jesse Liver
More's
Location: Board of Trade Courtyard

Ecowsystem

Artist: Sonya Baysinger
Patron: Warburg Dillon Read, Inc.
Location: Board of Trade, 12th floor

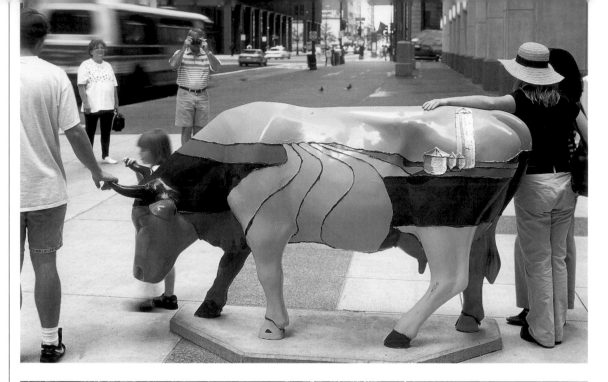

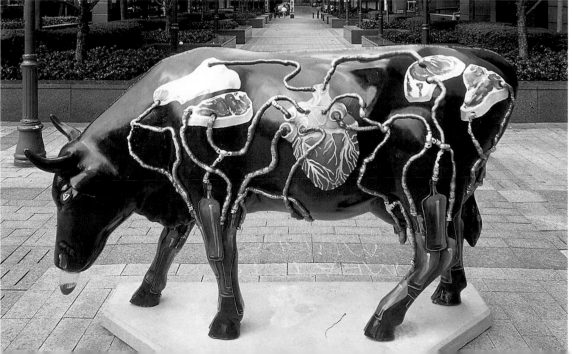

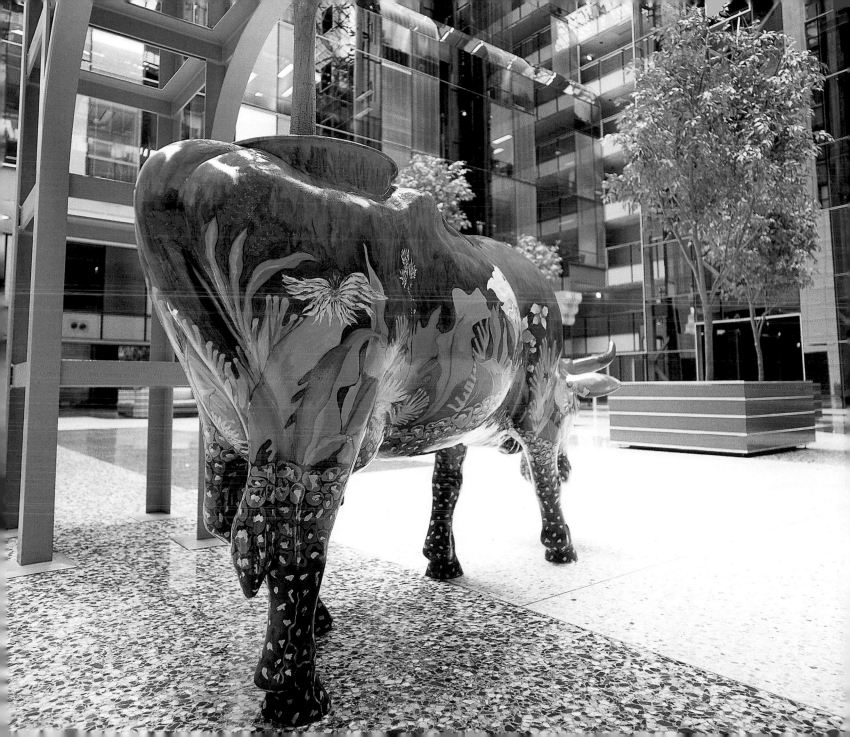

What a Relief Neighborhood Leaders

Artist: Adam Pincus
Patron: USG Corporation
Location: 222 W. Adams

Scenic Sally

Artist: Brian Ritchard
Patron: Skydeck Plaza
Location: 233 S. Wacker

PUN INTENDED

Piggy Bank Cow

Artist: Lohan Associates,
James Goodspeed
Patron: The Lurie Company
Location: 120 S. LaSalle, lobby

From «Udder Romance» and «Ecowsystem» to «Pi-COW-so» and «Moollennium» cow, wordplay has abounded. In fact, according to one count, there are 34 titles that rely on puns from cow-related words. «Piggy Bank», created by the achitecture firm of Lohan Associates and James Goodspeed, is a good example of conceptual art — clever, amusing and well-executed.

Butterfly Cow

Artists: Audry Crambit, Jim Weber
Patron: Melanie and Eric Hanig
Location: Clark and Monroe

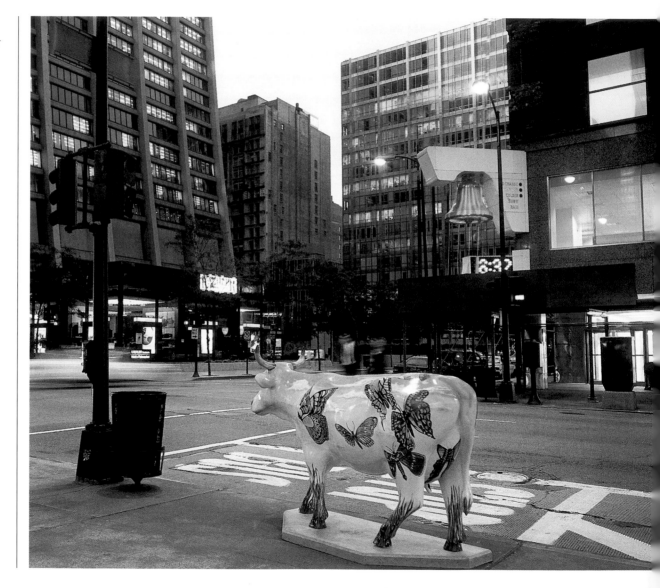

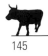

Moving Chicago for 100 Years

Artist: Grady-Campbell Inc.
Patron: Gatx Corporation
Location: Monroe and Canal
(NE corner)

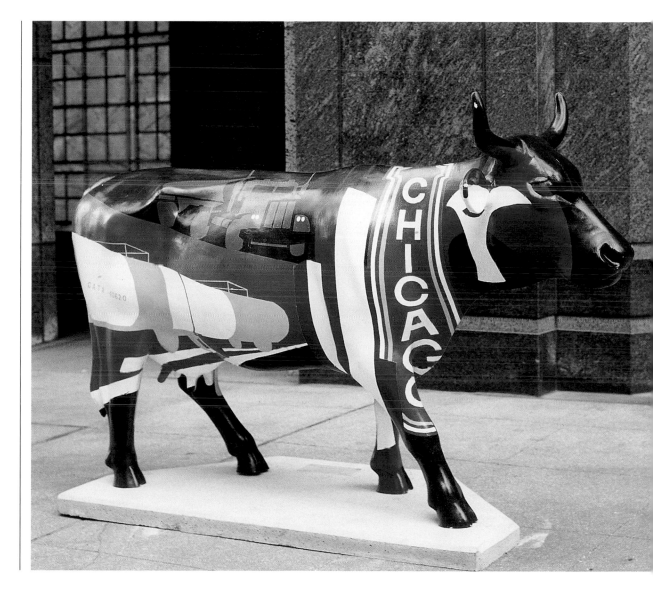

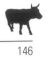

READY FOR A BULL MARKET

Carousel Cow

Artists: Scott Bullock and Ronit
Mitchell of Penumbra
Patron: Friedman, Goldberg,
Mintz & Kallergis, LLC
Stone, Mc Guire & Benjamin
Location: Clark and Madison,
SE corner

Spotting Famous Chicowgoans

Artist: Richard Laurent
Patron: USG Corporation
Location: USG Building, 123 S.
Franklin

Moocantile

Artist: David Winter
Patron:
Chicago Mercantile Exchange
Location: Monroe and Wacker,
NW corner

Open Mic Nite at Clairabelle's

Artist: Tom Fedro
Patron: Hotel Allegro
Location: Hotel Allegro, 171 W.
Randolph (look up!)

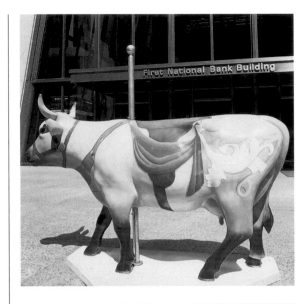

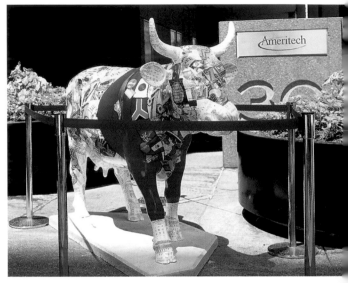

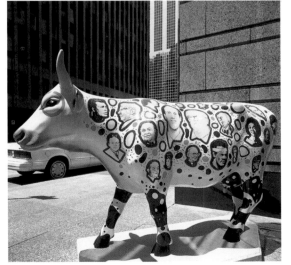

SOCIAL CLIMBERS

147

Toreador's Song

Artist: Robert Perdziola
Patron: Lyric Opera of Chicago
Location: Opera House, 20 N. Wacker

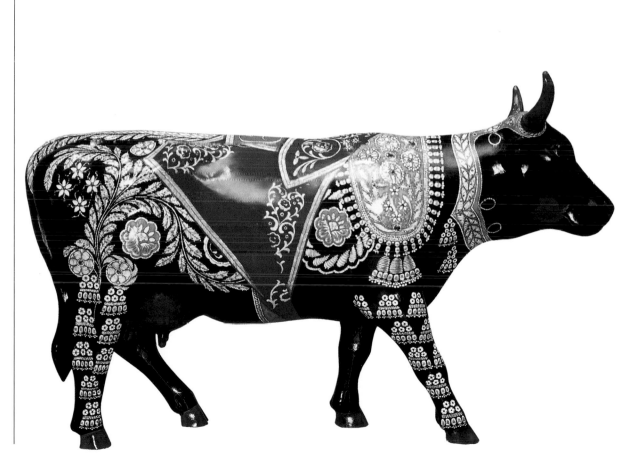

Cow Sandburg

Artist: Ken Indermark
Patron: Schwartz, Cooper,
Greenberger and Krause
Location: 180 N. LaSalle

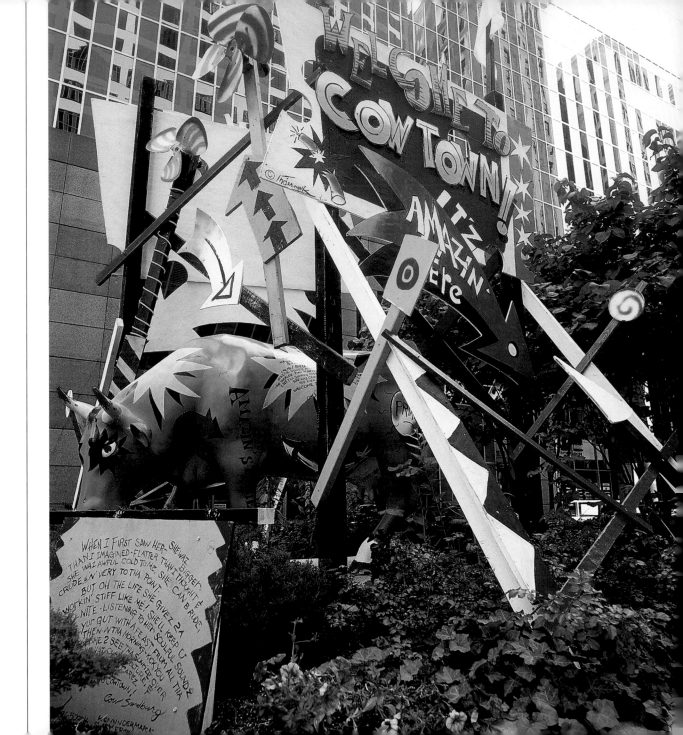

MOOSEUM CAMPUS

Mootif

Artist: Glenn Wexler
Patron: Chicago Park District
Location: Roosevelt Road and Lake Shore

Solar Cow Lantern

Artist: Arthur Myer
Patron: Chicago Park District
Location: Roosevelt Road and Lake Shore

Sacred Cow

Artists: Jennifer Zackin, Sopheap Pich, Sanford Biggers
Patron: Chicago Park District
Location: Roosevelt Road and Lake Shore

Jazz Chicago! Merci Henri

Artist: Joyce Martin Perz
Patron: Chicago Park District
Location: Roosevelt Road and Lake Shore

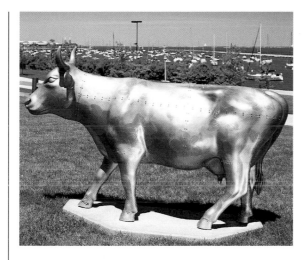

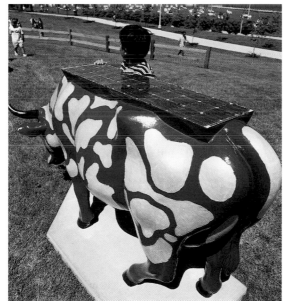

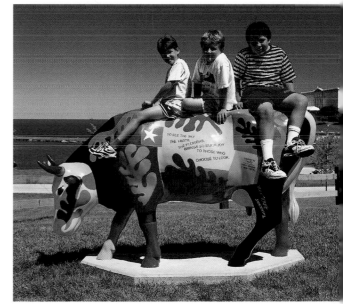

SPLENDOR ON THE GRASS

Gertrude's Magic Roundabout

Artist: Claire Ashley
Patron: Chicago Park District
Location: Roosevelt Road and
Lake Shore

Cafe con Leche

Artist: DZine
Patron: Chicago Park District
Location: Roosevelt Road and
Lake Shore

The Spring Cow

Artist: Alan M. Bolle
Patron: Chicago Park District
Location: Roosevelt Road and
Lake Shore

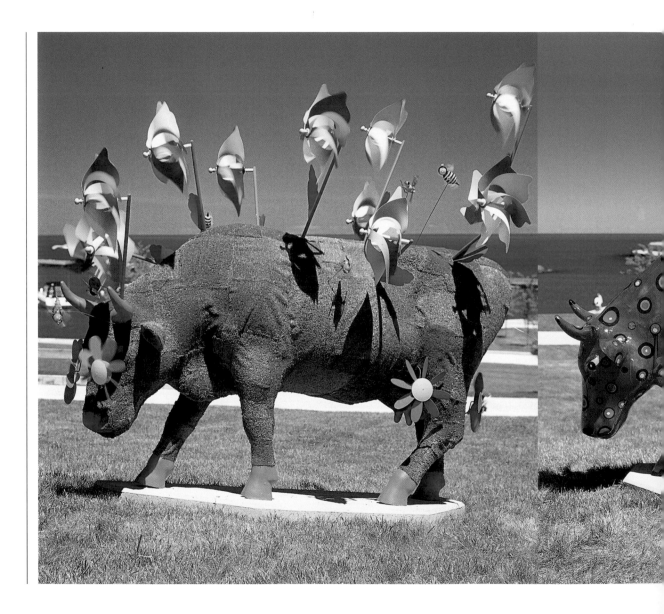

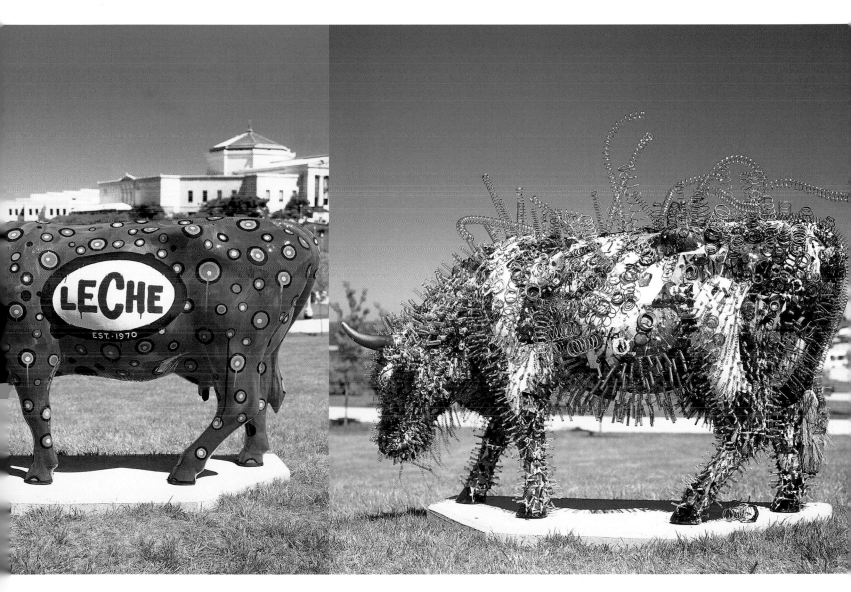

U.S.

Artist: Ann Wiens
Patron: Chicago Park District
Location: Roosevelt Road and
Lake Shore

Fruits of Summer

Artist: Shawn Finley
Patron: Chicago Park District
Location: Roosevelt Road and
Lake Shore

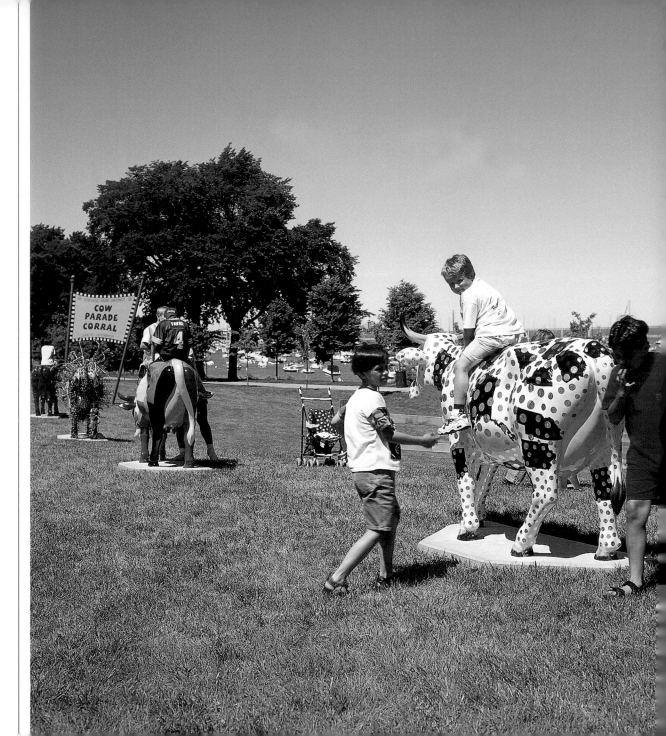

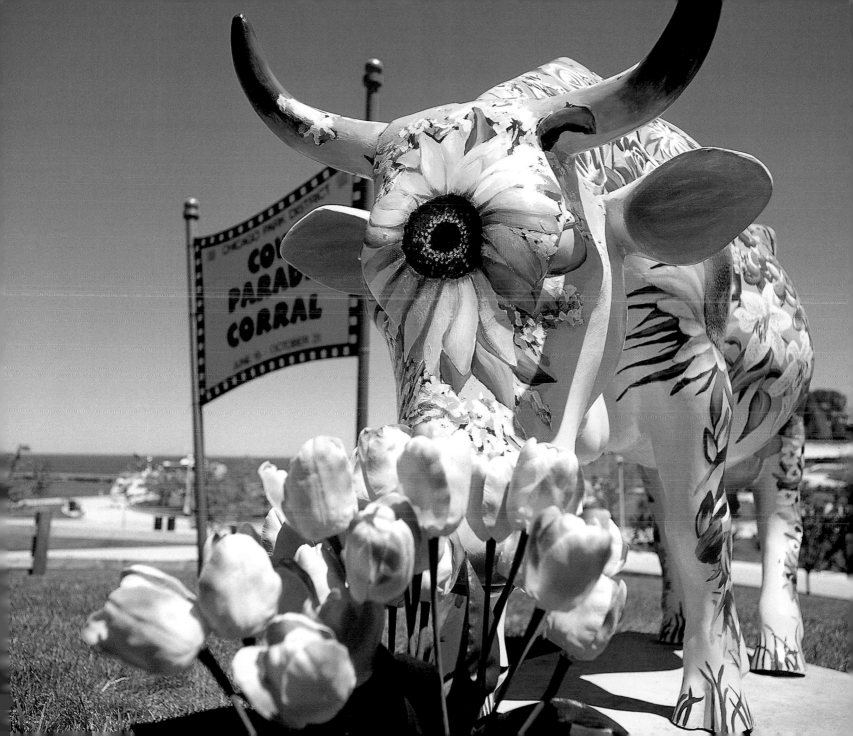

Bovine Messenger Service

Artist: Tim Brower
Patron: Chicago Park District
Location: 425 E. McFetric Drive

Mooving and Grooving

Artist: Beth Reitmeyer
Patron: Chicago Park District
Location: Soldier Field, south
entrance roof

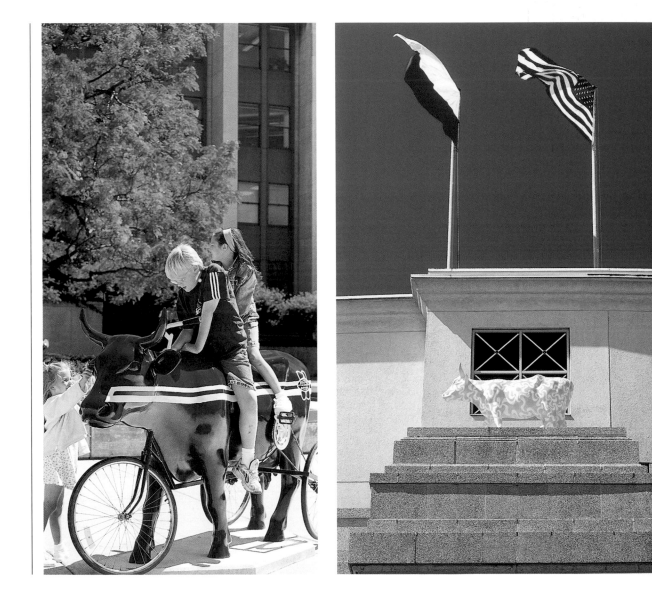

FIELD MUSEUM

Stick Cow

Artist: Martin Giese
Patron: Field Museum
Location: Field Museum

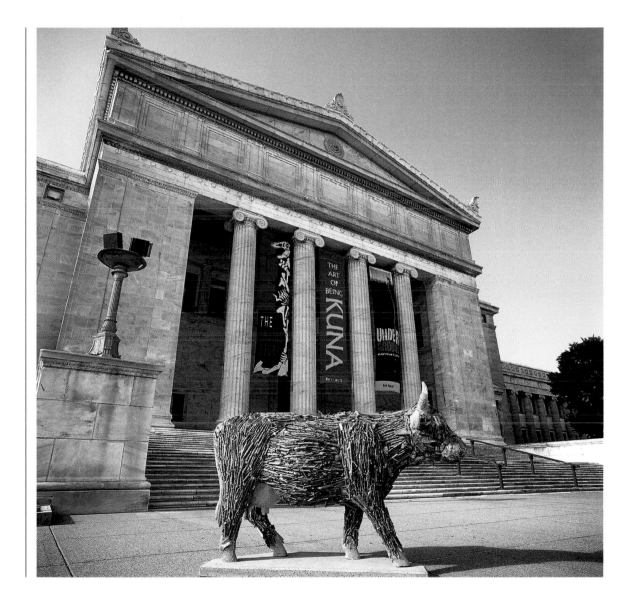

ADLER PLANETARIUM & ASTRONOMY MUSEUM

And the Cow Jumped into the Moon

Artist: Ronit Mitchell of Penumbra
Patron: Adler Planetarium
& Astronomy Museum
Location: 1300 S. Lake Shore Drive

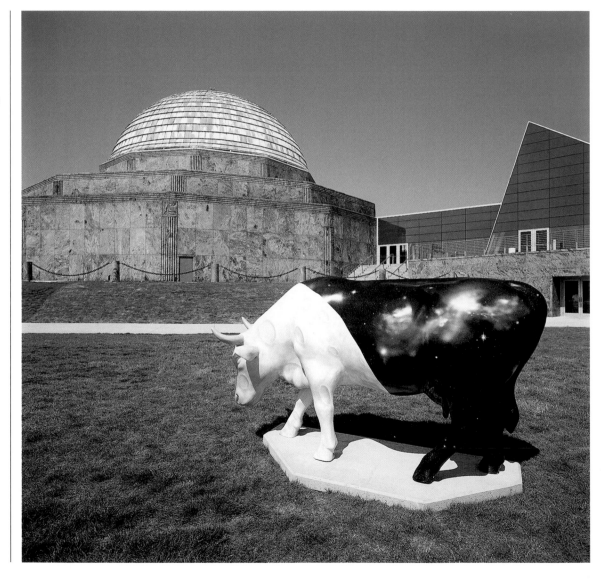

MCCORMICK PLACE

Chicowgo, My Kind of Town

Artist: Ann Primack
Patron: Metropolitan Pier
& Exposition Authority
Location: 2301 S. King Drive

Untitled

Artist: Peter Mars
Patron: Metropolitan Pier
& Exposition Authority
Location: 2301 S. King Drive

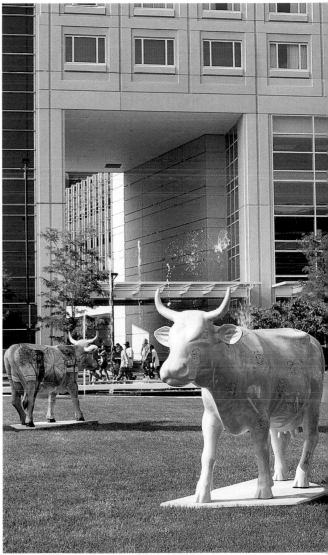

BEHIND THE SCENES WITH THE ARTISTS: THE MAKING OF COWS ON PARADE

Sometime around the end of February, the harbingers of Chicago's summer of 1999 arrived on cue: More than 300 white fiberglass cow forms were uncrated after the long journey from Switzerland and delivered to artists and architects across the city. Little did the artists know just how deeply the cows would affect them, how much time they would command and how completely these creatures – weighing in at a mere 45 pounds – would take over their lives. At that time, no one realized that their creative contribution would soon be part of the most popular public art exhibit ever to hit the city's streets. And certainly no one had any idea that the exhibit's whimsical, accessible art would give Chicago's favorite season a new moniker: «the summer of the cows».

City Dwellers Come Face to Face with Nature

Like all projects that have such a glorious ending, «Cows on Parade» had a rather inauspicious beginning – at least from the artist's point of view. More than one artist reports being completely overwhelmed by their initial encounter with the life-sized cow form. «My first thought was how am I ever going to get it into the elevator and up to my studio?» says Chris Hill. «I had never seen an actual, physical cow before and didn't think it would be as large as it was.»

But artists are an ingenious lot, and soon warehouses and storefronts, back porches and alleys, garages and dining rooms, public buildings and private homes were converted into ersatz studios – to the chagrin of partners and spouses, the bewilderment of family pets and the delight of neighbors who could watch the long strange works-in-progress from afar.

Hill finally wedged the cow into his Wicker Park studio, but for Carol Stitzer, who worked on the cow in her third-floor Old Town apartment, it was another story entirely. Both her formal dining room and her back porch were co-opted into studio service. Married artists Karl Wirsum and Lorri Gunn had dueling space needs at their house, but managed to reach a satisfactory, albeit comical, solution: one cow in the living room, another in the dining room. Meanwhile, collective spaces were set up for artists to work downtown. The city contributed the building at State and Lake Streets – which almost immediately became known as the «Cow House» – and for several months, the evolving cow art visible through the plate glass windows both tantalized and mystified curious passersby.

Starting Out –
With a Little Help From Swiss Friends

Finding a starting place for an ordinary art project can be daunting enough, but figuring out how to begin a cow – in your living room, no less – can be downright intimidating. At least that was the consensus of the artists after first confronting their cows. Fortunately, Chicago artists had the benefit of the Swiss experience. In addition to tips from the Zurich show, «cow kits» were also available. A Swiss paint company assembled packages of acrylic paint colors, primer and varnish – all of which had been weather-tested and cow-approved the previous summer – and a North Side art supply store offered them at a deep discount. For those 10 percent of artists who bought the kits, it became a starting point.

Cow as Muse

Nonetheless, for everyone involved, the real starting point was the idea itself. But where did the ideas come from? And how did 300 artists each begin with the same basic shape and arrive at such wildly different places? Some ideas arose organically from Chicago history, for instance, the Mrs. O'Leary's cows. Others came from irresistible plays on cow words or themes, like «How now brown cow» and «Hey-diddle-diddle». A few, including «Moo-net» and «piCOWsso», arose out of an artist's admiration for his or her predecessors, not to mention the obvious pun. Others were an original expression of the artist's philosophy, for example, «Colonized Bovine», or sharp observations on contemporary culture, like «Suit» or «Sacred Cow». Several – the Wrigley cows, for instance – were clever interpretations of the sponsor's product. The majority reflected the artist's working style, but quite a few also represented experiments with new materials, approaches and themes.

David Philpot credits the cow itself for his inspiration. «I tried to listen to what the cow was telling me because she shook off different things I tried to do,» he says. «In the end, I found I was just the conduit.» Philpot describes the day he hit the proverbial brick wall. After he had covered his cow from head to hoof with thousands of cowrie shells, buttons and beads, he finally reached the ears. He vainly attempted to give them the same treatment, but with no success. «I tried to force the beads on them», he recounts. «Boom. The cow said, ‹no.› After five days of thought, I painted her ears gold instead. Boom. The wife said, ‹yes›. The kids said, ‹yes›. The cow said, ‹moo›. You can see who won.»

wntown Chi-cow-

Function Follows Form

Philpot calls attention to a lesson artists learned early on: that it is useless to impose your will on the cow. Quite simply, the cow's form dictates the approach. Period. Chris Hill, for example, had done some preliminary sketches but found they weren't translating the way he had envisioned. Then he had his «aha moment». «I realized that I should be reacting to it as a cow, not as a canvas,» he says. The most problematic areas, the artists agreed, were the cow's prominent hipbones, which distorted lines and made it nearly impossible to transpose the original designs directly onto the cow.

But art is about nothing if not problem-solving, and the artists quickly switched gears to view the cow as a three-dimensional object, not a bovine-shaped canvas. «When you're working on a flat wall, it's one thing,» comments Stitzer. «But when it's on the hip of a cow, it's something else altogether. You adapt.» In a sense, adaptation became the watchword of the project. Tim Anderson had no problem envisioning the three-dimensional form, but he was concerned about being able to easily move his cow around the studio. He attached skateboards to the cow's hooves. Problem solved. Dennis Callahan, who worked on six cows simultaneously, was more concerned with efficiency. His solution? Fashioning

an assembly line so that while one cow was drying he could move on to the next.

Cows Under Construction

Regardless of the final outcome, the creative process itself was remarkably similar for all the artists. The first step was to apply a coat of primer to highlight flaws — for example, uneven spots where the ears and horns had been attached to the cow's body. Next steps involved sanding the cow, filling in the uneven areas, and applying a second coat of primer as well as a color base coat. Some artists substituted several layers of gesso to give the surface additional texture; artists working with beads or mosaic tiles applied a thick layer of industrial-strength glue or caulking instead.

Only then could the real work begin. And that's when the artists really starting putting in the long hours. Day after day, night after night, they painted, carved, molded, shaped, decoupaged and decorated their bovine beauties. Anderson painted 48 oil portraits of musicians on his cow. Stitzer painstakingly applied squares of copper leaf to hers. Linda Dolack pressed 40,000 crystal beads onto her «Rhinestone Cowgirl» while Barbara Koenen covered her «Sweet

Home Chicago» cow with 21,000 gumdrops. And Art Institute of Chicago student Thomas Jacobs hand cut 55 square feet of sheet glass into more than 10,000 mosaic pieces that he then attached to «This Is Not a Cow» one by one.

Some cows called for equal parts ingenuity and engineering from their artists – particularly those employing structural changes. Mark Hayward, whose Mrs. O'Leary's cow has a movable leg that kicks over a lantern, actually took a hacksaw to his cow, carefully carving off the left rear leg in order to build the hinge mechanism. He then constructed an elaborate system made of plumbing pipes inside the cow's hollow rear quarters and reattached the leg with fiberglass and heavy screws. In a similar vein, Kathy Kozan, whose cow has a newspaper vending machine in its belly, used welding tools to attach the boxes and urethane foam, fiberglass coating and polyester resin to create the cow's turn-of-the-century newsboy attire.

Solo Acts and Group Efforts

While the majority of cows were executed by individual artists, quite a few came to life as a result of collaboration. Wendy Pressley Jacobs turned the cow into an officewide project at her 14-person graphic design firm. Together, they brainstormed the original concept – a cow covered with quotes from famous Chicago writers standing next to a stack of books, all in the name of promoting literacy – then divided up the work: Three people researched quotes while two primed and painted the cow. One person outlined the shapes of the spots and two calligraphers applied the words. Another two staff members created the books, while still others applied finishes, worked out the engineering and attached the props.

Stormy Weather and Other Concerns

Part of the cow-creating process was finding ways to protect them from Chicago's volatile weather. «I was most concerned about water damage that could cause the paint to bubble and peel,» explains Callahan. He safeguarded his cows with a layer of shellac followed by two coats of protective finish. Almost all the cows in the show received similar coatings. The ones that were just too fragile for the elements were assigned indoor spots in building lobbies or protected public spaces.

Also top-of-mind for the artists was vandalism and normal wear and tear. Because so many of the cows have attachments – shoes, hats, earrings, a brief-

case, toys, a cheesecake, a fish platter, flags, pocketbooks, plants and pinwheels – artists also needed to craft replacement parts. Mark Hayward made five lanterns for his «Mrs. O'Leary's Cow»; Ken Aiken keeps a supply of metal glasses for his Harry Caray «Holy Cow» on hand.

The trick, however, was not to expect perfection for the duration of the exhibit. «What drove me crazy at first was that my work is very neat and precise – and this process wasn't,» says David Philpot. «I found myself wanting to replace every little piece that came off my cow, but then I realized that the imperfection of the cows was one of the appeals of the exhibit – that cows, like humans, show their day-to-day scars. That's when I finally let go.»

Separation Anxiety: The Cows Go Home

Indeed, letting go seemed to be the most difficult part for the artists – not the long hours, not the strange shape, not the unexpected glitches, not the awkward size. Only reluctantly did they surrender their pieces when the truck from the Public Art Program arrived at their doors. For many, their cows had become part of their families – co-existing in their living space for weeks on end, sharing their lives and challenging their artistic sensibilities.

They joked about having post-traumatic stress syndrome and wondered about starting a cow bereavement support group.

That's when the accessibility of «Cows on Parade» really hit home. Throughout the summer, cowsick artists could make pilgrimages to their cow, which made the loss a little more palatable. «This was a very different experience for me,» explains Chris Hill. «Usually my work gets sold, it goes into private collections and I never see it again. It's nice knowing that my cow will be around for a while and I can visit it whenever I want.»

Usually, however, the visits are part business, part pleasure – quickie «tune-ups» that involve filling in nicks, reattaching a horn or an ear, touching up the paint. Carol Stitzer has long stopped trying to replace the plastic lizards and frogs that originally sat on her cow's back, but she does like to freshen up the paint on occasion. «Afterall,» she says, «I have to keep her looking Michigan Avenue. You certainly don't want her to look shabby.»

Local Heroes: Artist As Celebrity

It's during these hit-and-run repairs that the artists feel the full impact their work has had on the public.

«Once people figure out you're the artist, they treat you like a celebrity,» says Stitzer. «It's really fun. People will introduce themselves to me, ask me about the project, want to take my picture with the cow … I've never experienced anything like it before.»

Mark Hayward calls the public reception extremely validating. «When your work is in a gallery people have to seek it out. With ‹Cows on Parade› people just stumble over it. It's a nice opportunity to get genuine reactions to my work.» And for many it's the most attention they've ever received for a piece of work. Artist Adam Brooks believes this is because the cows have become magnets for ideas and conversation. «There is so little public discourse about art in our culture today,» he says, «but the cows have opened it up in surprising ways. I think because there's a common form that links the pieces together, it has laid bare the creative process. People can see that everyone starts at the same point and reaches a different conclusion.»

David Philpot puts it into perspective. «For months you work up close and personal with the cow, but you only see parts of it at time. Then suddenly, it's out in the world and people see it in all its glory. They're reacting. They're happy. They're touching it and caressing it You begin to think that maybe you've done something here.» He's right. They – the artists – *have* done something here.

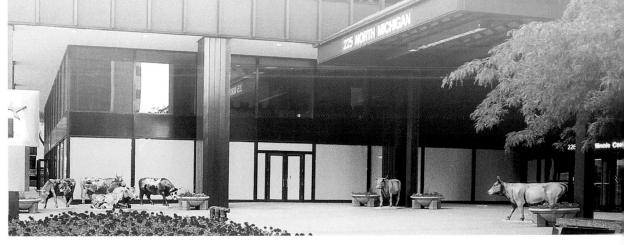

Music

Artist: Tim Anderson
Patron: Steve Ford Music
Location: 506 N. Clark at Grand

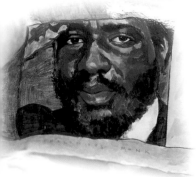

Balloon + Flowers = Fun Cow

Artist: Matt Lamb
Patron: Matt Lamb, Ltd.
Location: Superior and Franklin

Half and Half

Artist: Jared Joslin
Patron: Sotheby's
Location:
Ontario/Orleans/Ohio Gateway

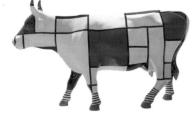

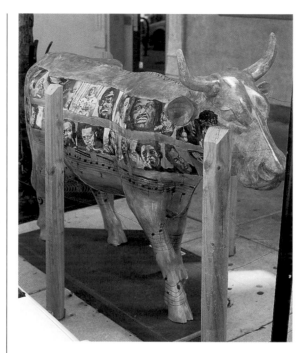

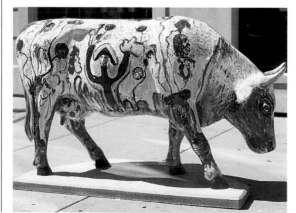

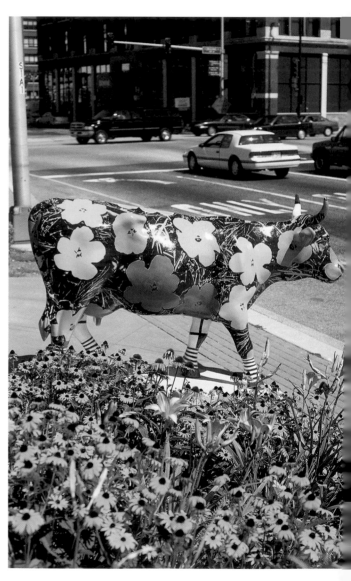

NORTH SIDE STRAYS

Blowing Winds of the Midwest

Artist: Christopher Tuscan
Patron: Chicago Historical Society
Location: 1601 N. Clark at North Avenue

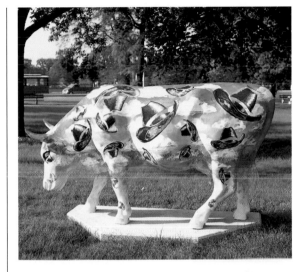

Mrs. O'Leary's Cow

Artist: Mark Hayward
Patron: Chicago Historical Society
Location: 1601 N. Clark at North Avenue

Dedicated to preserving, recording and exhibiting Chicago's relatively short history, the Chicago Historical Society – located at the south end of Lincoln Park – picked an appropriate cow to call its own. «Mrs. O'Leary's Cow» illustrates the dearly held legend of how the great Chicago fire of 1871 was started – a cow kicking over a lantern, which is exactly what this cleverly conceived bovine does when a lever is pulled.

The Conscious Cow

Artist: Skyline Design
Patron: Sherwyn's Health Food
Shops, Inc.
Location: 645 W. Diversey

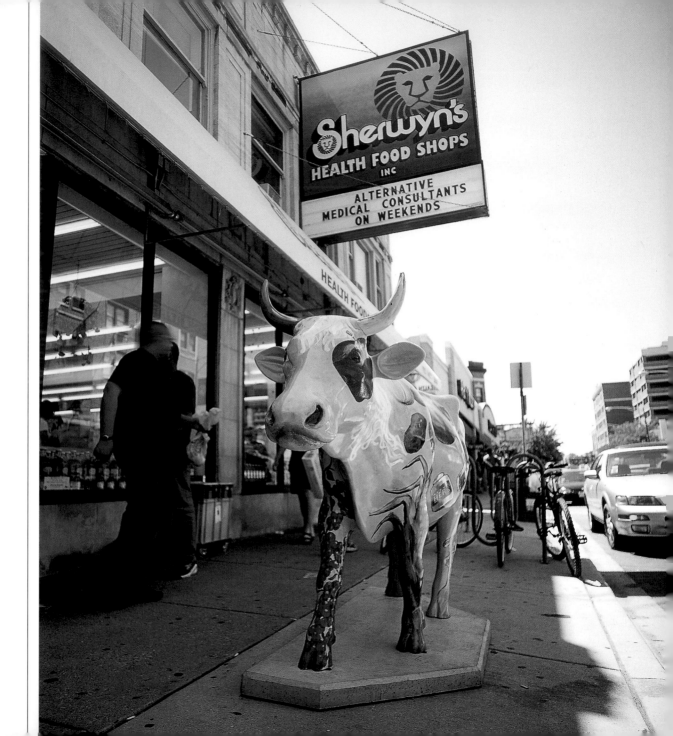

O'HARE AIRPORT
United Airlines Terminal

If Cows Could Fly

(look above the ticket counter!)
Artist: C. Jeff Hughes and the
Children of Mary Crane Center,
CHA, Lathrop Homes
Patron: United Airlines
Location: United Airlines Terminal

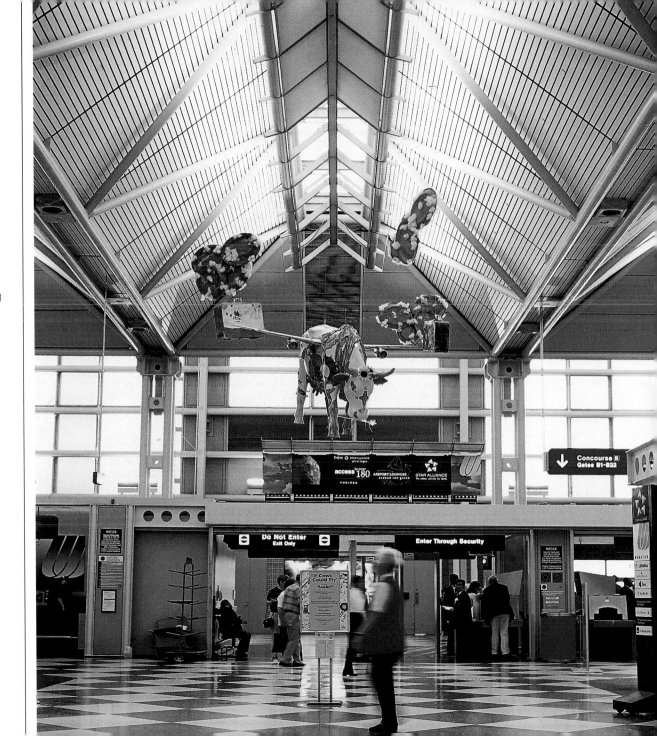

DaVinci Cow

Artist: Sandy Kowerko
Patron: Chicago Airport System
Location: International Terminal

This Is Not a Cow

Artist: David Moose
Patron: Chicago Airport System
Location: Midway Airport

The Cruisin' Cow

Artist: Scott Piper, EXO, Co.
Patron: LaSalle Bank
Location: Running around town

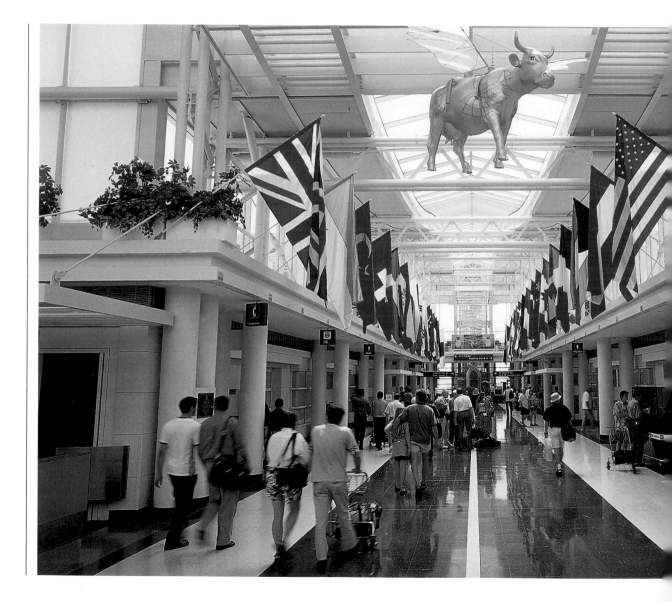

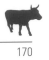

THE MUSEUM OF SCIENCE AND INDUSTRY: EDUCATING THROUGH ART

SOUTH SIDE STRAYS

Mooooonwalk

Artist: Craig Wartman, Robert Finzel
Patron:
Museum of Science and Industry
Location: 57th and South Lake
Shore Drive

Moo 505

Artist: Joseph O'Connor, Robert
Finzel
Patron: Museum of Science and
Industry
Location: 57th and South Lake
Shore Drive

Pioneer Heifer

Artist: Heather Hug
Patron:
Museum of Science and Industry
Location: 57th and South Lake
Shore Drive

Cow-leen Mooooore's Fairy Cowstle

Artist: Heather Hug
Patron:
Museum of Science and Industry
Location: 57th and South Lake
Shore Drive

Udderly Chic(k)

Artist: Craig Wartman, Robert Finzel
Patron:
Museum of Science and Industry
Location: 57th and South Lake
Shore Drive

COWS ON THE MOOVE

TRAVELING AROUND TOWN

Bernice, The Bovine Barn Burner

Artist: Scott Piper, EXO Co.
Patron: LaSalle Banks
Location: Traveling Around Town

Well Read Cow

Artist: Wendy Pressley Jacobs
Patron: Equity Office
Location: Traveling to Equity Office
locations

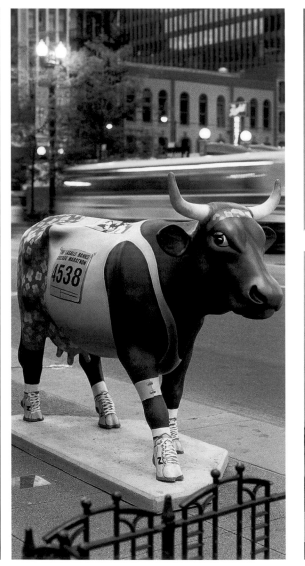

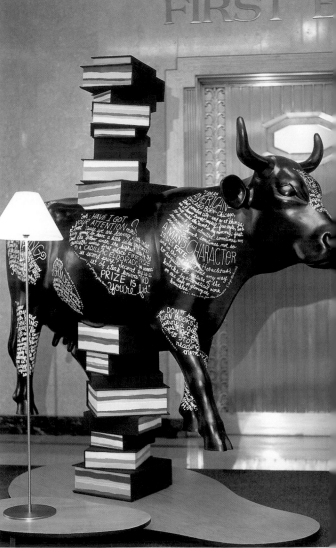

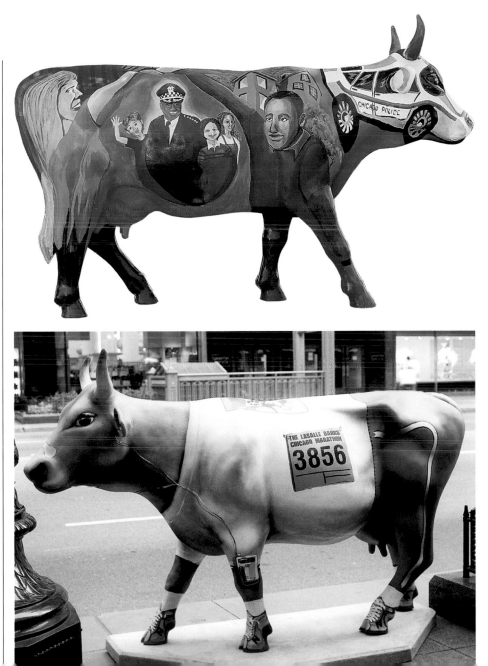

Community Cow

Artist: Gallery 37 Apprentice Artists
Patron:
Community Assisted Policing
Location:
Traveling to Branch Libraries

Moorice, the Udderly Quick Heifer

Artist: Scott Piper, EXO Co.
Patron: LaSalle Banks
Location: Traveling Around Town

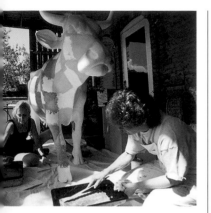

Duration of Exhibit:
«Cows on Parade» runs between June 15, 1999 and October 31, 1999.

Number of Cows in the Exhibit: 306

Cow Dimensions:
The hollow, unpainted fiberglass cows weigh in at around 88 pounds. The concrete bases that attach to the finished product add another 320 pounds, making them virtually unmovable without the proper equipment. Height of the standing cows? Approximately 56 inches.

**Amount of Time Artists Spent
Creating Their Cow:**
There are no firm numbers, but many artists report spending upwards of 100 hours on their cow.

First Cow to Make an Appearance:
The St. Patrick's Day cow, which was displayed in the «cow house» on State and Lake Streets during the city's annual St. Patrick's Day parade in mid-March. Used as a preview to promote the project, it has since been painted over, reincarnated to honor First Lady Hillary Clinton on a recent visit to town.

Number of Cows Commissioned for Another City's Permanent Art Collection:
Two. «Literacy Lucy: The Library Lactator» will go to artist John Santoro's hometown of Frankfurt, Illinois, to be displayed at the public library where his mother is head librarian. «Wilhelmina Delftina de Koe I, a.k.a. Blue Moo,» commissioned by the town of Fulton, Illinois' «Dutch Days Festival», a celebration of the town's Dutch heritage, will go in its public art collection at the end of the show.

Number of People Who Will See the Exhibit:
Unofficial estimates put the number of people viewing «Cows on Parade» at more than 10 million.

Highest Cows:
«Ecowsystem» on the 12th floor of the Board of Trade at Jackson and LaSalle Streets. However, for a brief time «Brian the Cow: Milk and Cookies» held the honor when it was temporarily displayed on the roof of the 30-floor Doubletree Guest Suites at 198 East Delaware.

Lowest Cow:
«The Accidental Tourist», which reclines at sea level on a tourist boat in the Chicago River.

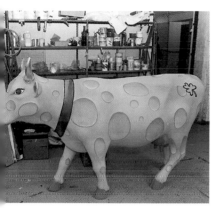

Sponsors of the Largest Herd:

The Chicago Park District with 12 cows – all of which can be seen at the corral on the Museum Campus.

Number of Cows in Chicago with Swiss Patrons:

Eleven, including cows by Swissôtel, Swissair, the Consulate General of Switzerland, Swiss Week in Chicago, Swiss Business in the Suburbs, Zurich Tourism and Ochsner International, a Swiss company.

Number of Mrs. O'Leary's Cows:

Officially, four – «Don't Blame Daisy» which stands, appropriately enough, in front of the fire station at 180 E. Chicago Avenue; Mr. Imagination's «I Did Not Start the Chicago Fire» on North Michigan Avenue; «O'Leary Memorial», which resides in Water Tower Park; and «Mrs. O'Leary's Cow», which is displayed at the entrance to the Chicago Historical Society at 1601 N. Clark Street. Unofficially, several other cows contain references to the Chicago fire.

Number of Picasso-Themed Cows:

Three – «piCOWsso» on North Michigan Avenue; «Pi-COW-so» in the Cow Moo-seum at the State Street Bridge Gallery; and «Guernsica» in front of the Goodman Theater on Columbus Drive.

Number of Cows on Buildings:

Five – «Mooving and Grooving» installed above the south entrance roof of Soldier Field; «Toreador's Song» atop a portico on the river side of the Opera House on 20 N. Wacker; «Open Mic Nite at Clairabelle's» climbing up a ladder on the facade of the Hotel Allegro, 171 W. Randolph; «Got Pizza,» on an awning at Gino's East, 160 E. Superior, and «Cowccinella Novemnotata,» on the facde of the Delaware Towers, 20 E. Delaware.

COWS BY ARTIST

LOVERS OF CHICAGO AND ITS WHIMSICAL COWS

As a publishing house based in Switzerland, we found coming all the way to Chicago to document the Cow Parade well worth the journey. We encountered tremendously kind and helpful people throughout the project, many of whom we are proud to consider our friends today. Without their help, this project would not have happened, and we are grateful for their support, as well as that of everyone involved. Working on the Zurich Cow Parade, which took place in the summer of 1998, was a wonderful experience. Working on the Chicago exhibit, however, showed us how far the limits of creativity and spontaneity can be exceeded – which is just one of the many reasons why we're bringing the Chicago Cow Parade to worldwide attention with this book.

The finished book is the result of the complete commitment of many people. We would especially like to thank the staff of the Cultural Affairs Department, the Swiss Consul General Eduard Jaun and his staff, the exhibit's initiator Peter Hanig, the author Mary Ellen Sullivan, and all the other «Cow Hands» out there. Unfortunately, we were not able to include all the existing cows into the book. Some weren't finished at the time our photographer visited the city, while others hadn't yet been installed. We kindly ask for your understanding regarding the details we were unable to include in this edition.

Hopefully you enjoyed «Cows on Parade» as much as we did, and it brightened up your day... and your summer. This book is meant to accompany you and keep the warm memories of the exhibit alive long after Chicago's «summer of the cows» ends.

H. Berchtold, Editor

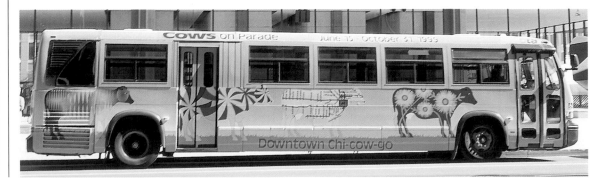